Children's Homage to Picasso

Children's Homage to Picasso

with 52 drawings by Picasso and
48 by the children of Vallauris

Text by Michael Batterberry and Ariane Ruskin

Harry N. Abrams, Inc., Publishers, New York

Standard Book Number: 8109-0397-0
Library of Congress Catalogue Card Number: 74-160122
Copyright 1970 in France by Éditions Cercle d'Art, Paris
Printed and bound in the Netherlands

PICASSO
AND THE CHILDREN OF VALLAURIS

The small sunny village of Vallauris lies just off the "Côte d'Azur," the "Blue Coast" of the South of France. The name Vallauris means "valley of gold," and it is said that there are bits of gold in the fine red clay that comes from its soil. But perhaps the clay itself is the gold of Vallauris. In ancient times, even before the coming of the Romans, this clay was used to make pottery that was sent all over the Mediterranean —pottery for cooking and all sorts of everyday uses. Until modern times, there were always pottery works in the town. But after the end of the Second World War, metal pots and pans began to take the place of pottery cooking vessels in France, and the potteries of Vallauris fell into disuse. Of the hundred that had been there, only twenty remained, and many of the potters, now out of work, drifted away. It is with this calamity that our story begins.

Shortly after the war, in 1946, the great Spanish painter Pablo Picasso spent the summer at the neighboring town of Golfe-Juan, on the coast. Picasso is one of the most versatile artists who have ever lived. One day, at the suggestion of

friends, he paid a visit to a small Vallauris pottery and, to amuse himself, decorated a few plates with pictures of fish, eels, and sea urchins. The following year his interest grew, and he went to work in earnest at the pottery, experimenting endlessly with the red clay. He produced new forms, and looked for new methods of glazing, although he still employed the wood-burning kilns, the ovens that the potters of Vallauris had used for centuries. The eyes of art lovers everywhere were now turned upon the village where the master was busily at work, and the potteries of Vallauris came back to life.

Picasso eventually came to live nearby, and the children of Vallauris, many of them the sons and daughters of the potters who owed so much to Picasso, knew him well. They saw him often in the streets of the town, and they knew his works. His pottery designs were everywhere to be seen (along with many poor imitations, unfortunately), and his statue, *Man with a Sheep*, stood in the village square. So it was that to honor Picasso's eighty-fifth birthday, they offered him a special gift—their own paintings and drawings. They were joined in this project by the schoolchildren of Golfe-Juan, and the subject they chose to paint for him was one he himself painted often—the bullfight.

Picasso has always had a passionate love of the bullfight.

And although he no longer visits his native Spain, he has for many years attended the bullfights given in the ancient Roman arenas at Nîmes and Arles in southern France. Then, too, once every year a bullfight is presented in the central square of Vallauris itself, so that the children of the town all know the excitement of the bullring and have often seen Picasso cheering in the crowd.

So delighted was Picasso with the hundreds of pictures he received that he chose his favorites among them and suggested that these, along with some of his own bullfight pictures, be collected in this book. But before you look at the pictures, you may want to know more about bullfighting, about Picasso, and about the pictures themselves.

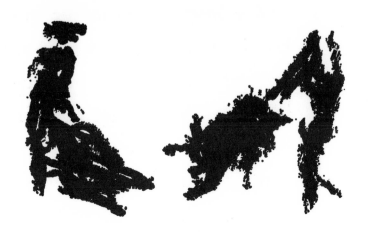

ABOUT BULLFIGHTING

The bullfight has a long history. Many ancient peoples of the Mediterranean worshiped bulls, among them the Sumerians, who lived five thousand years ago in the fertile valley between the Tigris and Euphrates rivers, their descendants, the Babylonians, and the peoples of ancient Persia. Perhaps because of its great bellowing roar, which sounds like thunder or the tremor of an earthquake, the bull was to them a symbol of the life force and of power. For this reason the bull was also a favorite animal of sacrifice. The Greeks thought that Poseidon, their god of the sea, liked to have a black bull slaughtered in his honor. It may be because of this that the bullfight came into existence—man challenging the power of the bull, trying to dominate it and sacrifice it to his gods.

There is an ancient Greek myth that Zeus, king of the gods, came in the form of a bull to steal away Europa, the daughter of the king of Phoenicia. He carried her on his back to the island of Crete, where they had three children, one of whom became Minos, king of Crete.

Minos was said to keep a monster, the Minotaur, half man and half bull, as prisoner in an especially constructed prison—

a maze from which there was no escape. Every year, seven youths and seven maidens, sent as tribute from the city of Athens, were sacrificed to the Minotaur. Deep in this maze, called the Labyrinth, the Minotaur awaited them, and none could find their way out. The story goes that one year, Theseus, son of King Aegeus of Athens, arrived to challenge the Minotaur. Minos's daughter, Ariadne, fell in love with the young hero and devised a way for him to confront the Minotaur and still escape from the Labyrinth. She gave him a ball of twine, of which she held one end. As he searched for the Minotaur, Theseus unwound the ball, and when he had slain the monster, he was able to find his way out of the Labyrinth by following the trail of the twine he had unrolled behind him. Ariadne was poorly rewarded for her efforts. Theseus took her away with him to the island of Naxos, where he deserted her, and sailed for home.

For over two thousand years the tale of this first "bullfight" was thought to be only a myth. Then, at the end of the last century, it was discovered that there had indeed been a great civilization on the island of Crete—one that was powerful during the second millennium B.C., a period that to the later Greeks was an era of myth. This civilization came to a sudden and mysterious end around 1400 B.C., and in the ruins of its greatest palace, called the Palace of Minos at Knossos, archae-

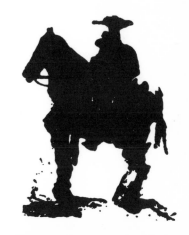

ologists found the most extraordinary paintings. Clearly depicted in brilliant colors, young men and women can be seen sommersaulting over the horns of a huge black bull. Were these the youths and maidens sacrificed yearly to the Minotaur? One thing is certain: there was, in ancient Crete, a ceremony in which men challenged, with their skill, the power of the bull.

But today, when we think of bullfighting we think of Spain. And it may be that the Phoenicians, the great Mediterranean navigators who were close neighbors to the people of ancient Crete, brought the combat of bull and man to Spain, where they had established colonies. In any case, we know that bulls and the custom of fighting them to prove one's bravery, were important in Spain from earliest times. When Hamilcar, the Carthaginian general and father of Hannibal, besieged the town of Ilici in the third century B.C., the native Spaniards (the Celtiberians) relied on ther wild bulls for defense. They attached torches to the horns of an entire herd and drove it stampeding down on the invaders. Hamilcar was killed, his army routed, and the fame of Spanish bulls spread throughout the ancient world. Julius Caesar presented bullfights to the Romans, and the Emperor Augustus had a special stadium constructed for *taurilia*, as they were called. The fiercest bulls came, as always, from Spain.

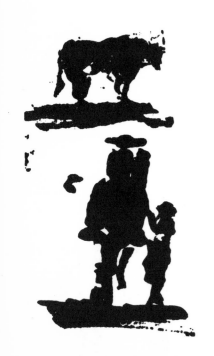

Although Spain was invaded again and again over the centuries—by the Germanic Goths, the Moors of North Africa, and others—the bullfight remained the national sport. The legendary Spanish hero of the eleventh century, El Cid, fought bulls on horseback, and so did the Emperor Charles V. The great *fiesta* of the bullfight had become a part of Spanish national life.

Gradually, over the centuries, the form of bullfighting that can be seen today came into being. In medieval Spain, only noblemen fought bulls to the death. At that time, wild bulls were tricked into captivity with the use of herds of domestic cows. The cows were taken into the countryside where the bulls ran free. Toward the end of the day, the cows would be driven home and the bulls would foolishly follow them into the city, where their fate awaited them in the central square the next afternoon.

Depending on the number of bulls and the importance of the occasion to be celebrated—such as a coronation or the king's birthday—as many as twenty young noblemen wearing velvets, lace, diamond-banded plumed hats, and scarves of their ladies' favorite colors might be killed in a single bullfight. These early bullfighters, called *toreadores*, were expected to prove their valor in the plaza, the city square, as elsewhere in Europe knights scored their strength and courage in tournaments.

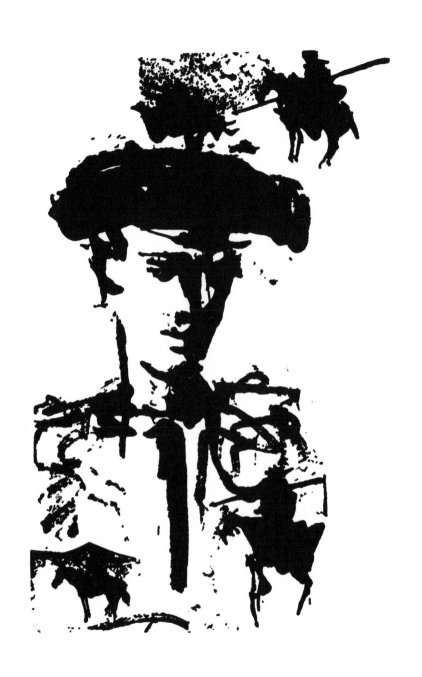

For years the Church condemned the courtly tradition of bullfighting, and eventually King Philip V of Spain forbade his nobles to practice the dangerous sport. But not even an order from the king could stamp out the Spanish passion for bullfighting, and from that time on the nobility's place in the plaza was taken by the country villagers who had formerly assisted their masters by fighting the bulls on foot. In this way, bullfighting became a professional rather than a chivalrous sport.

It is generally agreed that Francisco Romero, a young carpenter's apprentice whose daring performance in the plaza began to be noted by writers in 1726, was the first of Spain's many great professional bullfighters. Romero delighted the public not only with his strength and bravery, but with two totally original ideas that he brought to bullfighting. The first was the use of the *muleta*, a light wooden shaft less than a yard long, over which a cape or soft red flag was draped and manipulated in such a way that Romero could make the bull pass him as he wished it to do. His second important and lasting break with the customs of the past was to face the bull head-on and kill it with a single thrust of his sword.

Today the *corrida*, as bullfights are called, is almost always held in a bull ring rather than in a city square. During the last century the *corrida* became more popular than ever, and to

meet the demands of a paying public all over Spain and Spanish America, bull rings were built along the lines of amphitheaters, the circular stadiums of ancient Rome.

Seeing a bullfight today is like taking a trip into Spain's past, just as watching an American rodeo makes our imaginations race back to the colorful days of the Wild West. Led by an official riding on horseback and dressed in a billowing black cape, string boots, and a plumed hat, the entire company of bullfighters makes its entrance to the crashing blare of a brass band and the cheering of the crowd.

A bullfighter's dazzling costume is known as the *traje de luces*, the "suit of lights." The colors may vary, but each of these gleaming satin suits is stiff with gold and silver embroidery and sparkles with jewels and other rich ornaments. Wide sashes, short jackets, tight knee breeches, silk shirts and stockings, narrow black neckties, and shoes like dancers' slippers are as typical of the bullfighter's costume as his famous flat-topped black hat and flaring pink and yellow cape.

The stars of the afternoon (the *corrida* always begins at four o'clock) are the three *matadores*, each one of whom will fight and kill two bulls. Which matador has to fight which bulls will have been decided earlier in the day by a method which is much like our drawing straws. After bowing to the judges and the audience, the men take safe positions behind the

wooden barrier that runs around the ring and await the heart-stopping moment when the first bull thunders out of its darkened pen into the slanting afternoon light.

The actual fight itself is divided into three parts. In the first part, the matador and his assistant try to discover such individual traits in the bull as whether he jabs with his right or left horn or whether his eyesight is bad. The *picadores* then enter on padded, blindfolded horses and prod the bull into a fighting rage by pricking him with a dull lance, a holdover from the medieval knight's weapon. The trumpet sounds and the picadores leave, signaling the second part of the fight, which is performed with long paper-frilled darts called *banderillas*. The banderillas are planted into the bulls back by a *banderillero* on foot, an extremely dangerous trick to perform, and the trumpet sounds again. Now comes the battle between man and beast, the matador and the bull. The courage of both is tested in a series of passes in which the matador narrowly escapes injury with each sweep of his *muleta*. Sometimes luck is not with him, and he finds himself thrown over the bull's horns. But the fight always ends with the death of the bull,

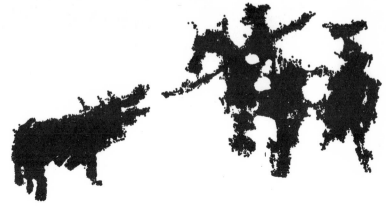

the roar of the crowd, and the removal of the bull's body from the ring by teams of mules fitted out in brightly colored trappings.

Outside of Spain, many people think of the bullfight as a cruel and unfair spectacle in which a poor beast is tormented and killed before a heartless crowd. But for Spanish natives, the *Fiesta Brava*, or Brave Festival, holds a deep and powerful meaning. For them, the contest between man and bull represents the triumph of human courage, grace, and skill over animal fury and brute force. In other words, for Spaniards the bullfight is really a ceremony in which the human spirit is pitted against danger and violence.

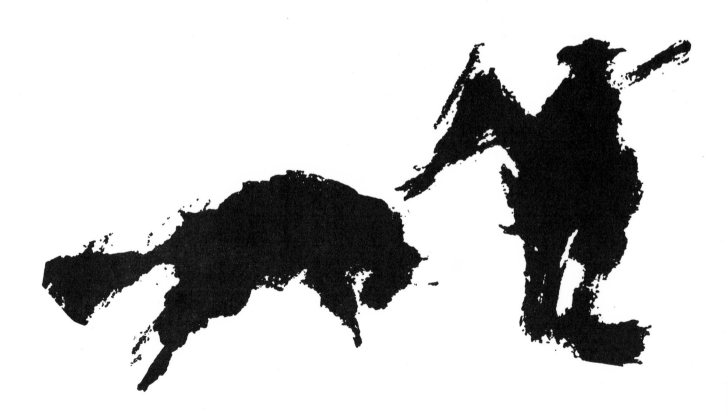

ABOUT PICASSO

No artist in history has tried to paint and draw and sculpt in more different styles than has Pablo Picasso. If we study his work over the last seventy years, we can see many of the most important changes in the art of this century.

Pablo Picasso was born in Malaga, a southern province of Spain, in 1881, the son of an art teacher, José Ruiz Blasco, and his wife, Maria Picasso. Even as a boy, Pablo amazed everyone with the excellence of his drawing, and by his twelfth birthday, it was said that he could do as well as professional artists twice his age. At fifteen, Pablo gave his first exhibition in Barcelona, and in the same year, 1896, the first article about this talented young painter was published in a Spanish art magazine.

Picasso discovered Paris and a whole new world of art on a trip to the World's Fair in 1900. Immediately he began to experiment with the bold, original styles to be found in the French capital. In 1904 he settled there to work, renting a studio in Montmartre, the picturesque artists' quarter perched high on a hill overlooking the city. By this time, Pablo had adopted his mother's family name when signing his canvases

and drawings. Perhaps he did this in recognition of her great faith in him ever since childhood. Years later, he liked to repeat what she had often told him as a small boy—that if he wanted to become a soldier he would certainly be a general, while if he chose to become a priest, he would end up as the Pope. Pablo's boast was that instead he had decided to become a painter and had ended up "as Picasso."

When an artist works in one style for a certain length of time and then stops, the pictures or sculptures he has created during that time are known as the works of a specific "period." Picasso has had many, many such "periods." His first, which began after a second visit to Paris in 1901, is called the "Blue Period." In this series of paintings, he used sad blues and grays to show the achingly sorrowful, grim lives of helpless poor people, such as beggars, blind men, and cripples. Next came the "Rose Period," in which Picasso's paintings were peopled with circus performers, harlequins, acrobats, bare-back riders—many of them glowing in a light the color of

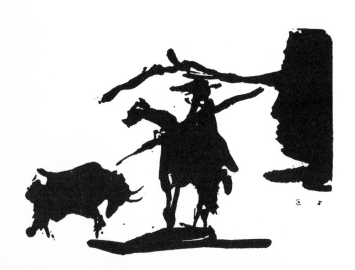

pale pink bricks. The "Rose Period" was rapidly followed by his "Negro Period," influenced by African masks from the Ivory Coast, and then by an even more revolutionary style called "Cubism," which Picasso invented with his good friend, the French painter Georges Braque. The Cubists took subjects such as the human figure, broke them down into fragments, and then put the fragments together in a way that was supposed to show objects from different angles and moving in space all at the same time. Very few people understood this movement at first, and Picasso became known as a painter of very strange pictures. This reputation increased following his experiments with "collage," yet another art form invented by Picasso and Braque.

The word "collage" comes from the French word meaning "to paste," and that is exactly what Picasso began to do—pasting bits of newspaper, cloth, string, and other odds and ends to his canvases to create an entirely new kind of picture. This method is still being copied today, more than sixty years

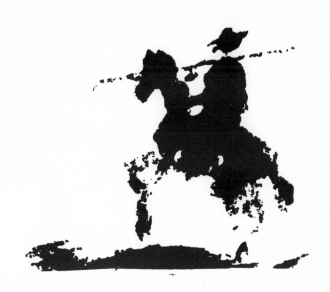

later. Picasso has always hated to throw anything away, no matter how unimportant it might seem to anyone else. Because of this, the most extraordinary materials have found their way into his endless artistic experiments. A soccer ball, for example, became a baboon's stomach in one of Picasso's sculptures, and in a large glass case that he calls "my museum," his visitors have been surprised to find, among other things, little painted matchboxes and glasses, engraved stones, and miniature stage sets complete with actors no bigger than pins —all the work of Picasso himself.

With equal ease, Picasso seems able to paint pin-actors, pottery, or such enormous masterpieces of wall art as his *War* and *Peace*, which dominate the chapel at Vallauris, or *Guernica*, his tragic mural showing the horrors of war. He painted *Guernica* in memory of an ancient city of that name destroyed by bombs in 1937, during the Spanish Civil War. The scene it shows is one of pain and terror: a woman carrying her dead baby screams into the night sky, a second woman, her dress on fire, plunges from a burning house, while still others peer and grope desperately into the fire and darkness. A single bare electric light bulb illuminates a wounded horse rearing in anguish over the broken body of a soldier with the stump of a sword still clenched in his fist. Unmoved by the terrible scene before him, a huge bull is seen snorting and bellowing

like a monster in a bad dream. Clearly, the artist has meant this wild-eyed creature to represent the senseless violence of war. Bulls, bull skulls, and Minotaurs reappear in many of Picasso's pictures, and almost always they are meant to suggest violence, evil, or death.

While Picasso has time and again used the bullfight as a subject for pictures, he has never meant these pictures simply to illustrate bullfighting in a realistic way. Any photographer can do that. Instead, what Picasso has managed to do is to show us the excitement and activity of the bullfight through his free, sweeping lines and bold, rapid brushstrokes. In his hands the bullfight springs to life and we feel the charging weight of the bull, the sudden fear of toppled horses and picadors, and the hissing, flapping, swirling grace of the matador's cape.

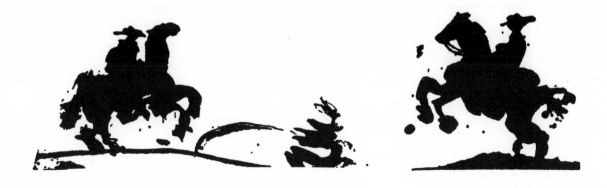

ABOUT THE PICTURES

In the following pages, Picasso and the children of Vallauris present us with a hundred different scenes of the bullfight, from the arrival of the first spectator in the early afternoon until the last moment, when the body of the defeated bull is drawn away by mules, and the matador, his arm raised in triumph, salutes the cheering crowd.

The bullfight makes a perfect subject for the artist, whether he is Picasso, one of the children of Vallauris, or you. Like moon shots, the ballet, or the circus, the bullfight presents an exciting combination of activity, setting, and costume. But such subjects should never tie us down to the simple task of recording details. Instead, they should act as a kind of trampoline for the imagination, allowing our thoughts and feelings about them to bounce around freely and tumble into our pictures.

Certainly this is how Picasso makes subject matter work for him, as you will see when you study his drawings in this book. In each of these, Picasso's bold lines and dramatic forms make us feel the terrific energy of the bullfight. Look, for example, at illustration 97. How wonderfully Picasso makes the bull

charge and lunge beneath the matador's cape by drawing its proud horned head in two different and powerful positions, one on top of the other, like a great wave rising and crashing on the shore. See how simply Picasso creates a ring full of dazzling light and shadow in number 81, and how in number 86 he re-creates with several rapid brushstrokes the awful moment when the bull tosses the matador on its horns. With a few lines only, Picasso manages to describe the terror of the picador's horse (56, 81, 83, 93). In 56, he points out the topsy turvy predicament of a fallen picador and his horse in what seem to be fragments—the broken straining line of the horse's neck and the stretchy rag doll figure of its master, for example, sum up the desperate commotion of the scene. With equal speed and simplicity Picasso shows us many other views of the bullfight, including the picking of the bull, the capework, the planting of the *banderillas*, and the final scene of the matador's victory.

Among the materials used by Picasso in the drawings are charcoal, pencil, brush, pen, india ink, a coffee-brown ink called sepia, and a special chalky-white crayon. The children, on the other hand, have used watercolors, tempera, or colored crayons.

In this book the children's pictures are presented side by side with those of Picasso. As you turn the pages, you might

try to recognize the similarities and differences between the work of Picasso and that of the children, and the differences between the children's pictures themselves.

Many similarities will strike you instantly. Most of the children have seen the bull much as Picasso himself saw him, as a silhouette, a menacing black shape. To one child he is blue, and to others he is brown. In some paintings he is standing still, and in others the children have captured the force of his charge. To Marie-France G. (17) and Patricia D. (77), he is beaten and about to fall. But in every picture the dark form of his body attracts all eyes—the spectators', the bullfighters', and our own.

You may notice, too, how Picasso turns the bullring itself into an open place, only suggesting its shape by the gently curved line of the walls (sketches 1 and 3). But to many of the children the bullring is a full circle, as if it had been seen from a low-flying helicopter. Maybe they felt that by painting the bullfight in this way they could show everything that happens inside the bullring at the same time. Or perhaps they simply thought that, because they *know* a bullring is round, it should be shown as a circle, even though the entire circle of the ring cannot be seen from the ground. Some, like the painters of pictures 7 and 54, show us both the inside and the outside of the bullring. Patricia L. (89) has even painted the cars that

brought people to the bullfight, as well as the crowd in the upper tiers.

What about the great crowd of spectators? Surely, representing such a large number of people would be a challenge to any artist. Many of the children, like Picasso himself, have suggested the crowd with a flurry of dots. This is the impression that a quick glimpse of it might give us. Francette M.-L. (45) has painted many small heads and neatly arranged them in circles, like French candies in a box. Still others have painted miniature figures. Marius S. (67) has shown us an audience made up entirely of men in sombreros (wide-brimmed Spanish hats), while in Françoise L.'s audience (54) we find only girls!

We can see, too, that some of the younger children, like Christian M., who was eight when he painted picture 96, and Dominique D., who was six (99), have simplified the scene, showing only what is most important—the bulls, the matador, and the crowd. It is the older children who sketch in for us many of the details—the bullfighters' uniforms, the building of the bullring itself, the waving flags. But what is most important, each child has seen the bullfight in his own special way and has shown us what was most important to him.

How would you paint a bullfight? The answer to that would certainly depend on what you consider to be the most

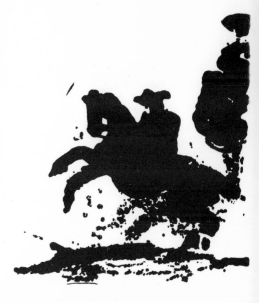

unusual, beautiful, or exciting part of the performance. Like Picasso and nine-year-old Martine C. (69 and 70), you might simply decide to portray a fighting bull all by itself. Or, like Picasso and Michel B. (46 and 47), you might single out the fateful moment when the matador, his *muleta* lowered, stands alone facing the bull before delivering the final thrust.

Look at all the children's pictures once again and you will see more clearly what has particularly interested each of them. Jean-Paul C., for example, must love horses. In his pencil and watercolor painting (60) he has taken great pains to provide the picador's horse with blinders and heavy blue padding. Marie-Antoinette R., on the other hand, has obviously been thrilled by the entrance parade of the bullfighters (94), while Monique R. was more impressed by the noisy enthusiasm of the crowd (42). In Monique's bullring we find a litter of hats and flowers, tossed there by the bullfighter's fans, and in the four corners of her picture appear cries of "Toro, Bis, Bravo, Hollet" (Bull! Do it again! Bravo! Hooray!"). Still other children have included in their pictures (24 and 82) advertisements for dried milk, coffee, cheese, and aspirin that they had noticed behind the barrier.

Seen together, the children's pictures are like invitations to their own special world, the same magic world which first captured the imagination of Pablo Picasso before our century

began, a world where sunshine, flapping flags, yellow sand, and a sea of smiling faces are made to mingle with memories of ferocious black bulls, sharp *banderillas* and the dangerous duel between man and beast.

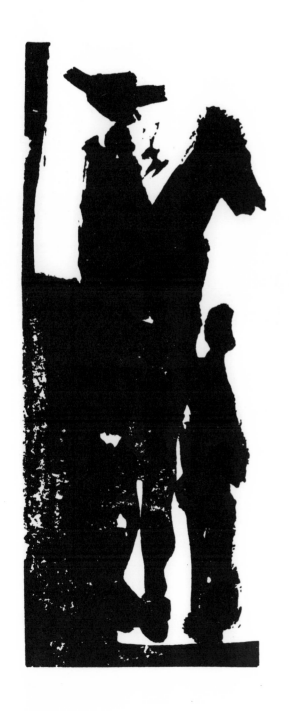

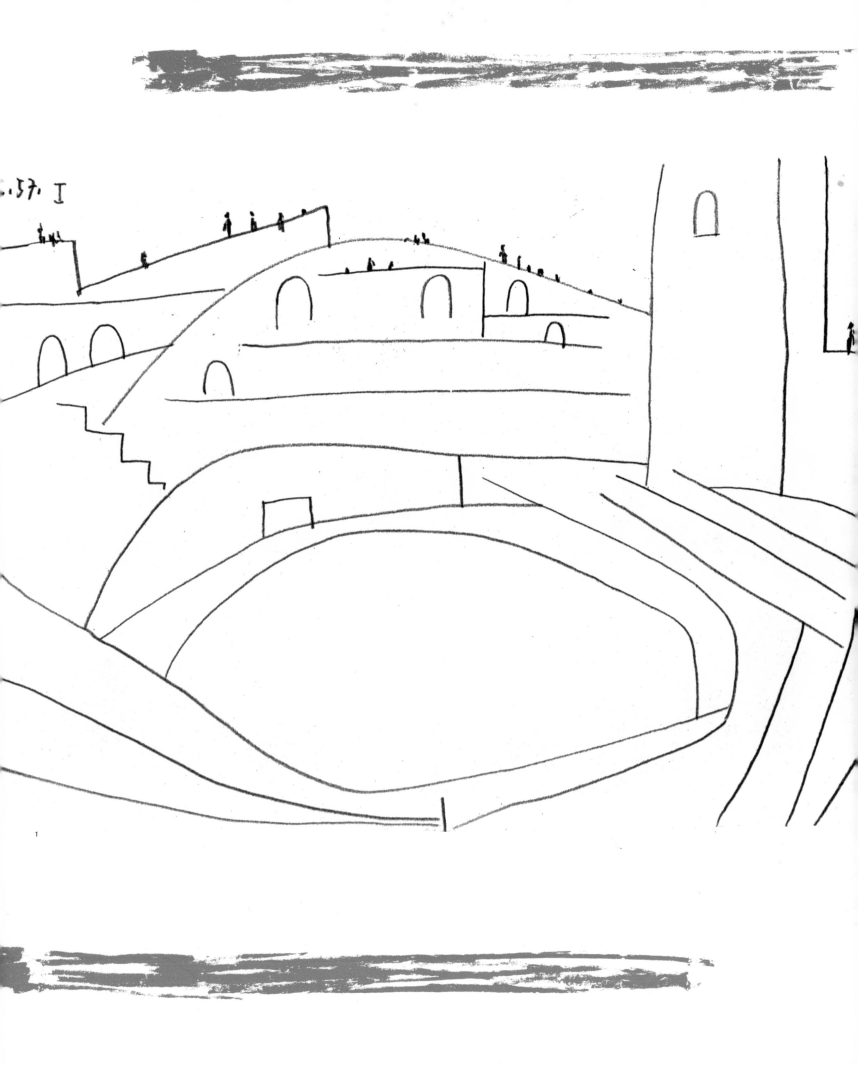

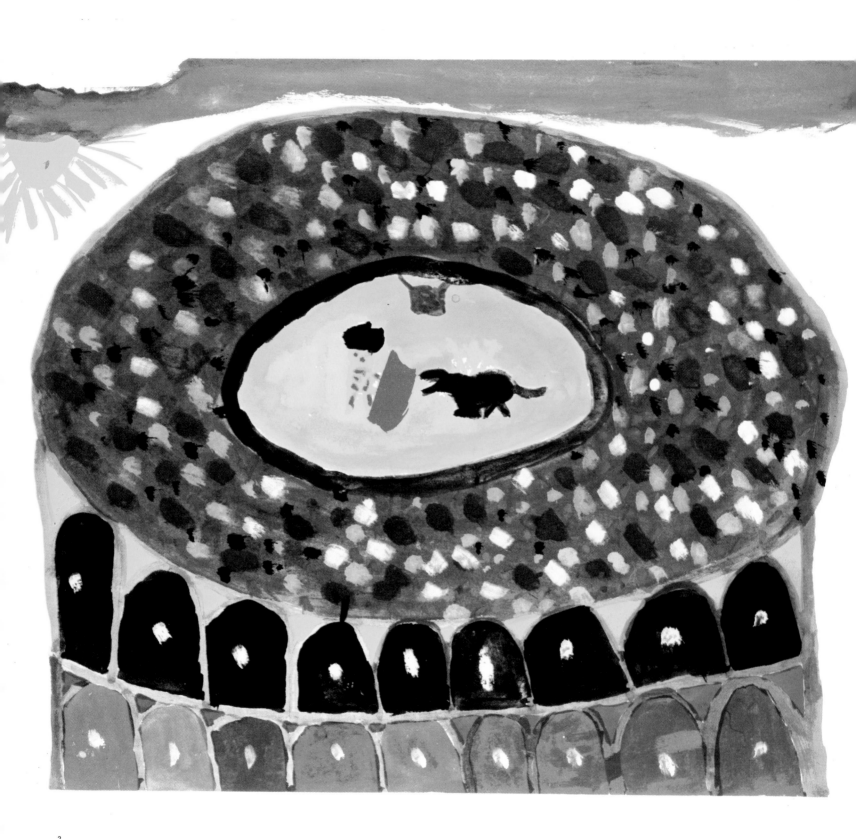

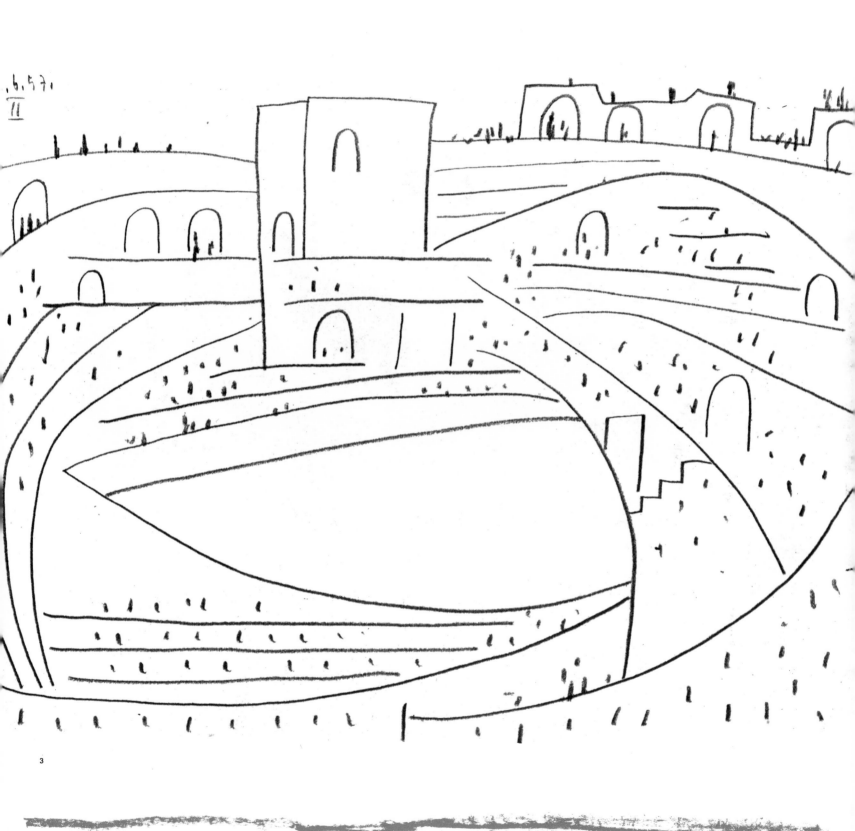

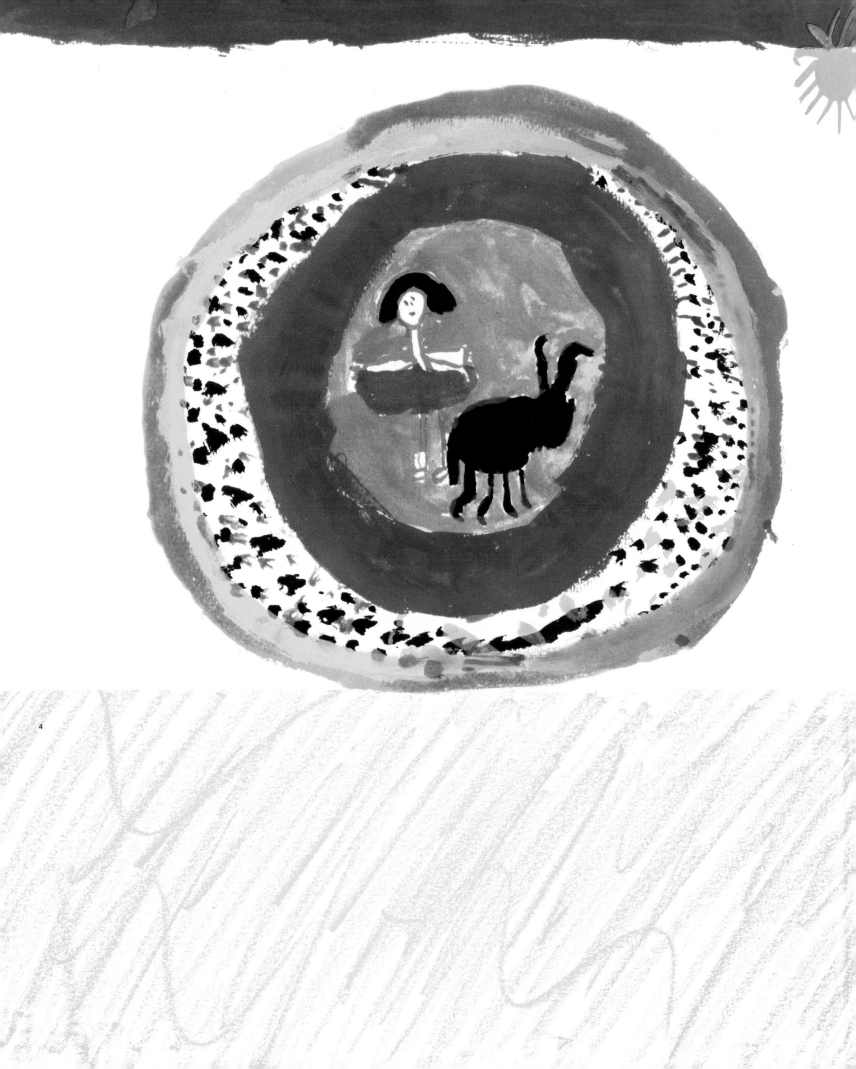

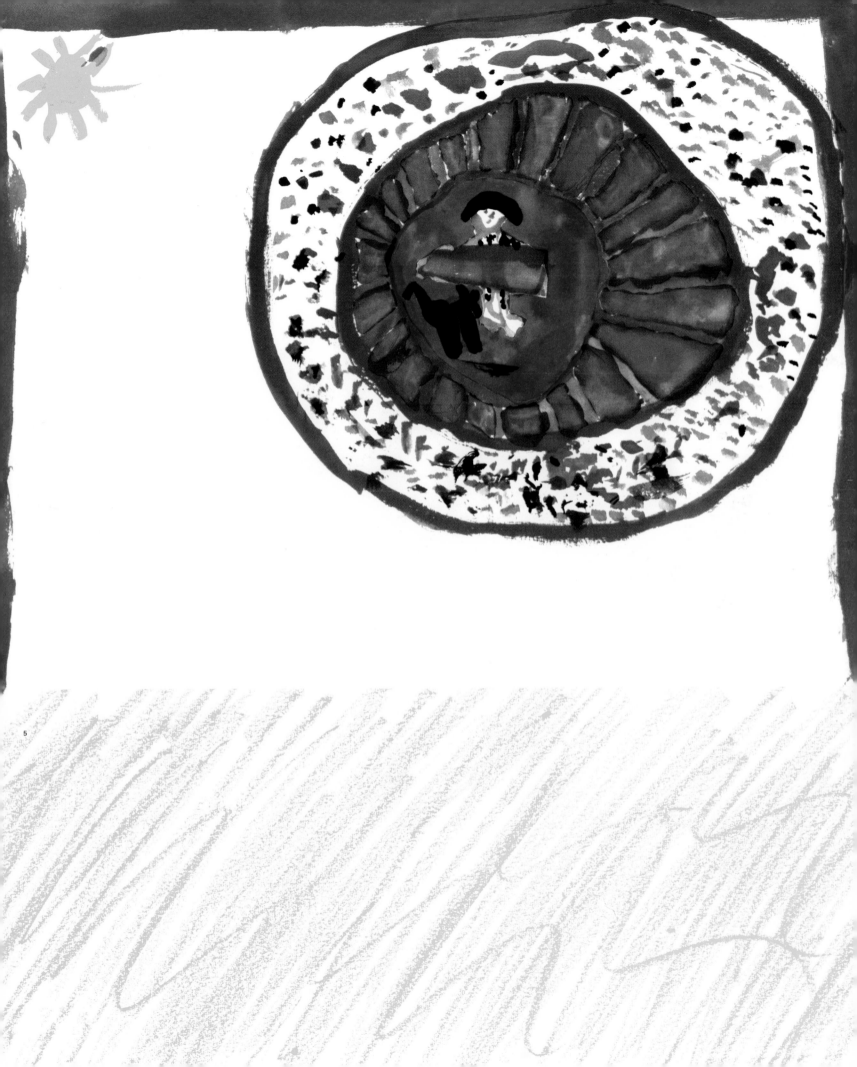

5

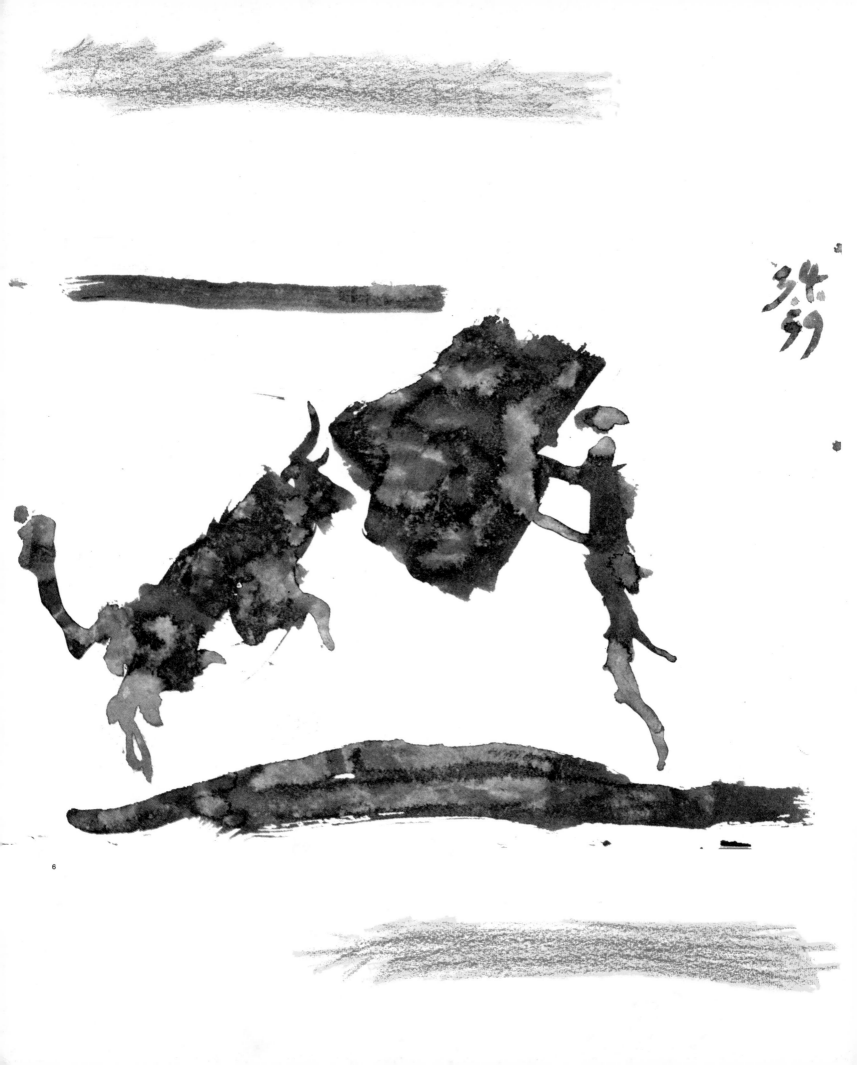

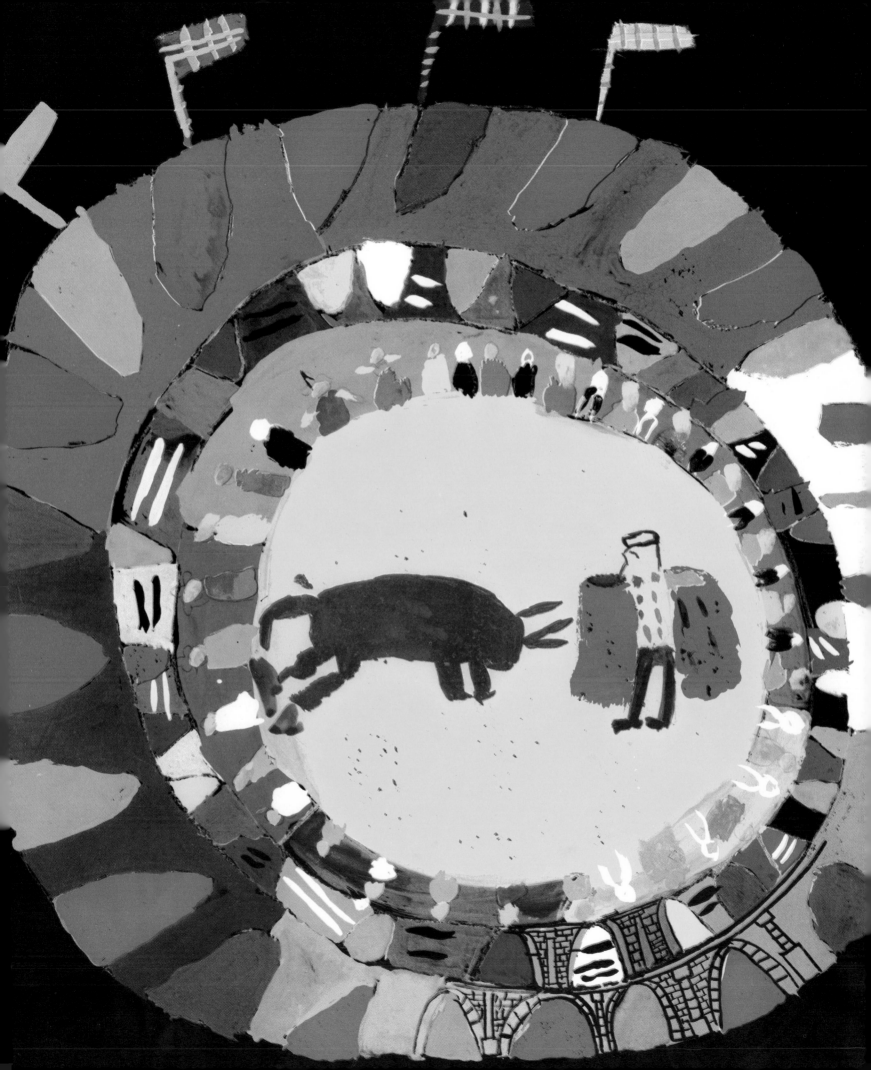

3·4·59

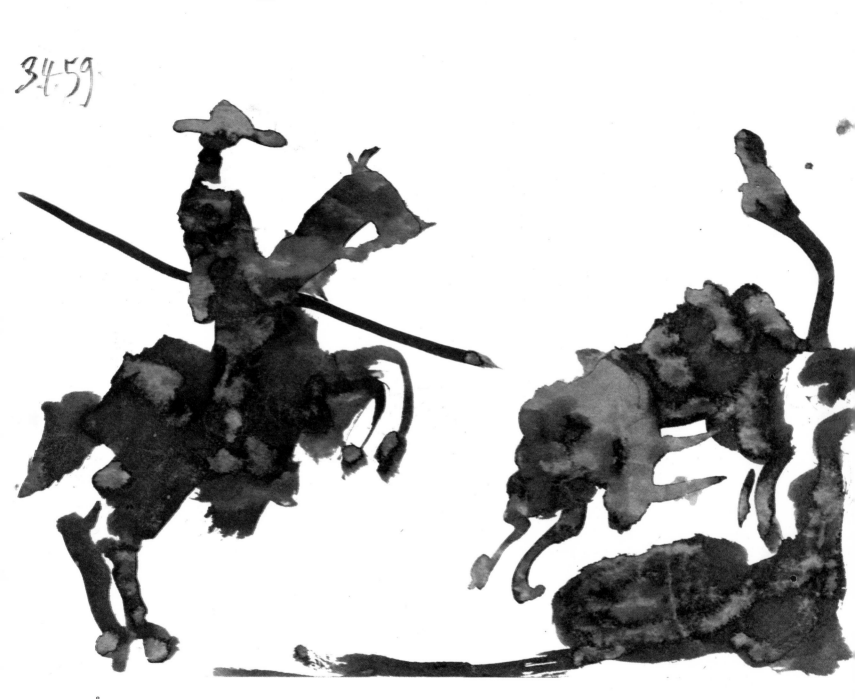

8

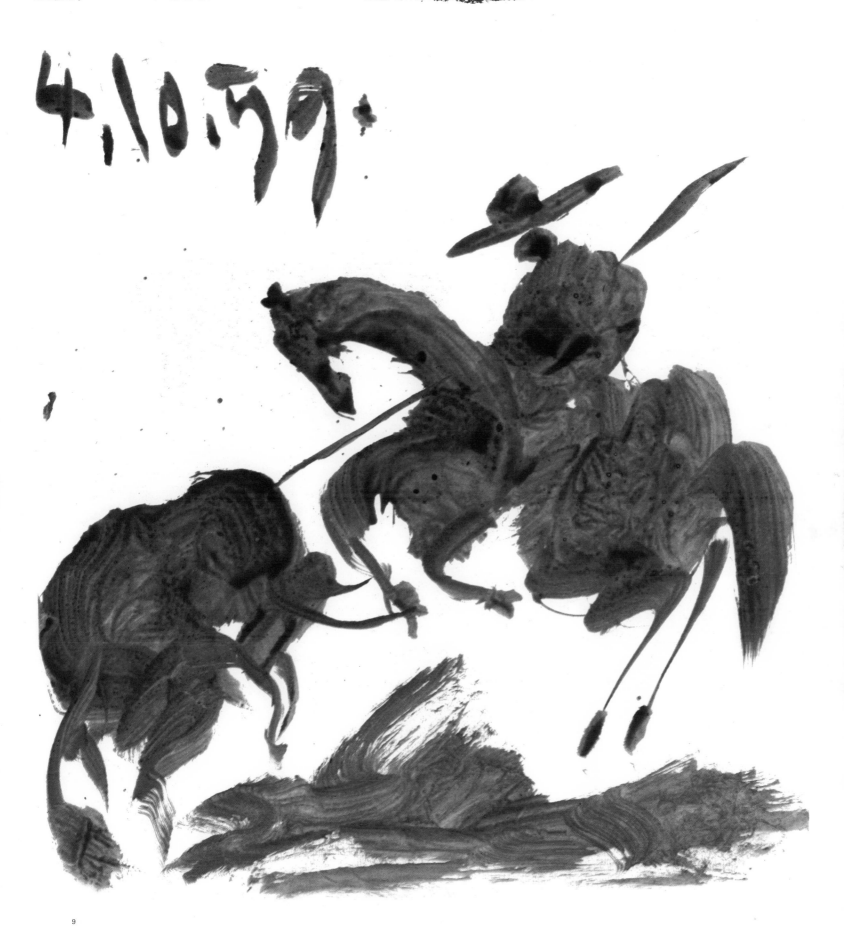

9

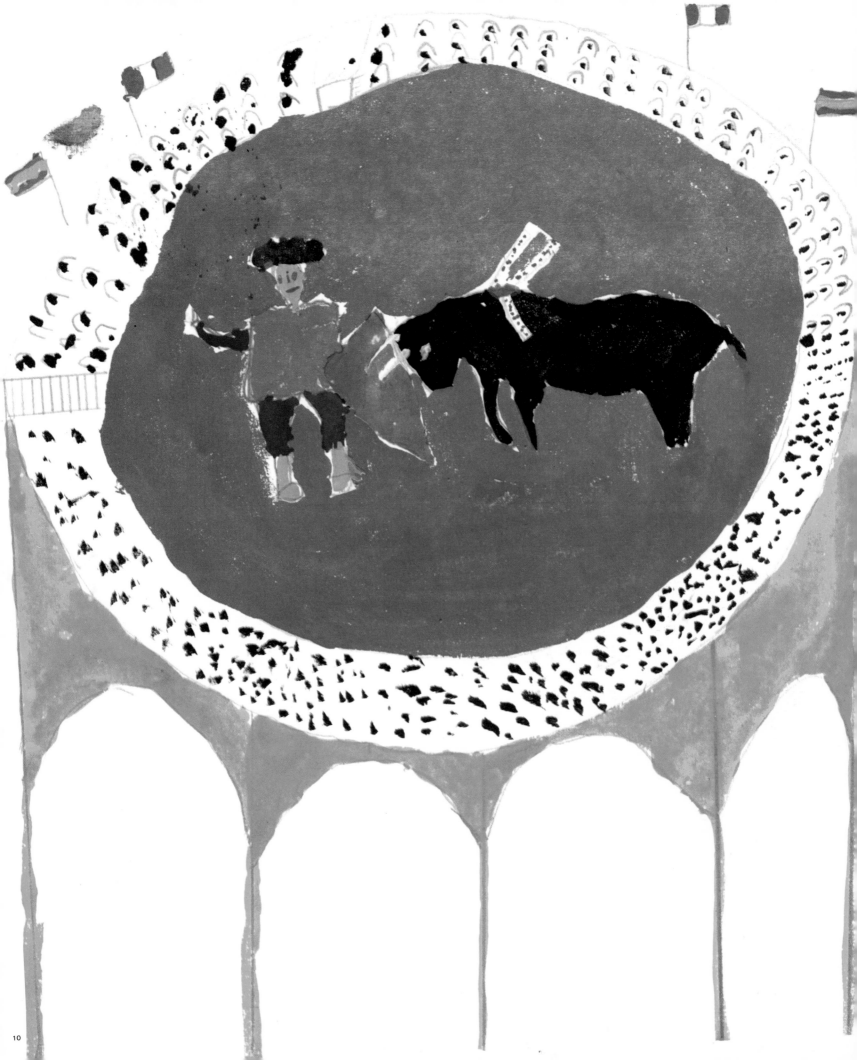

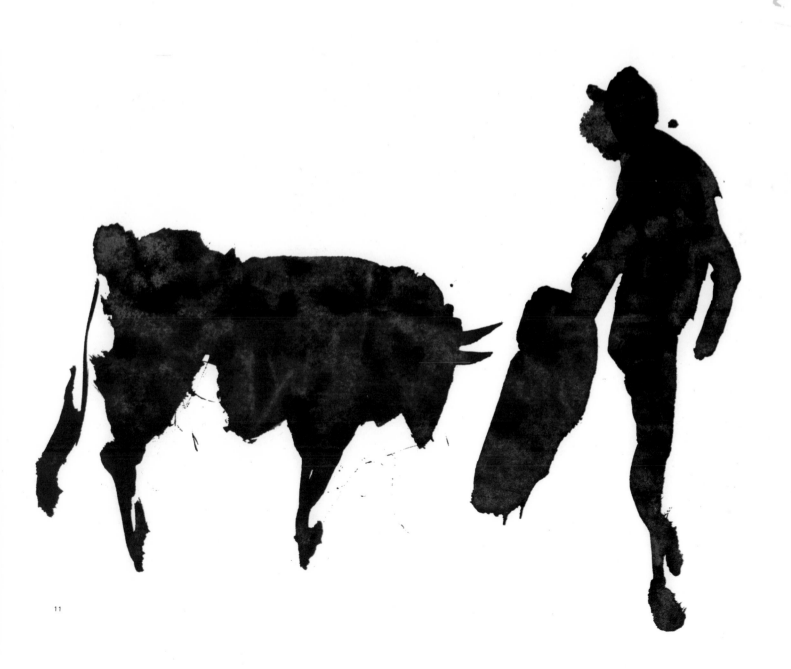

11

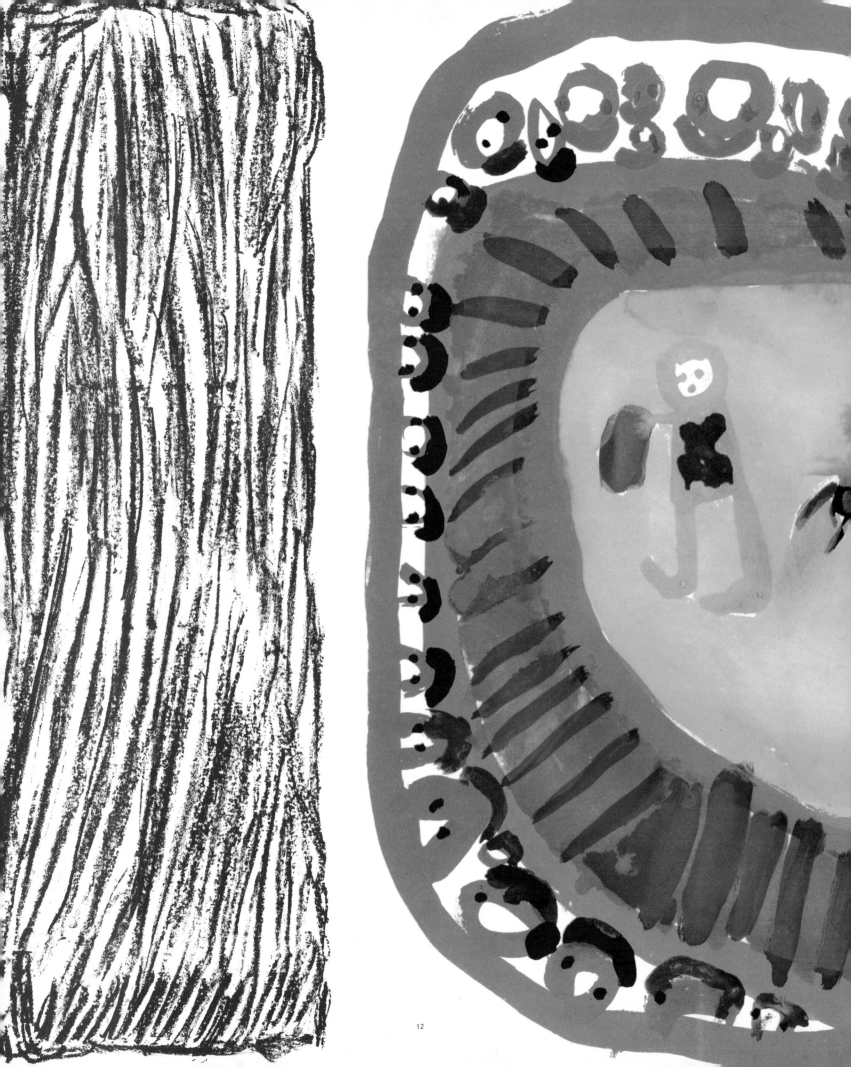

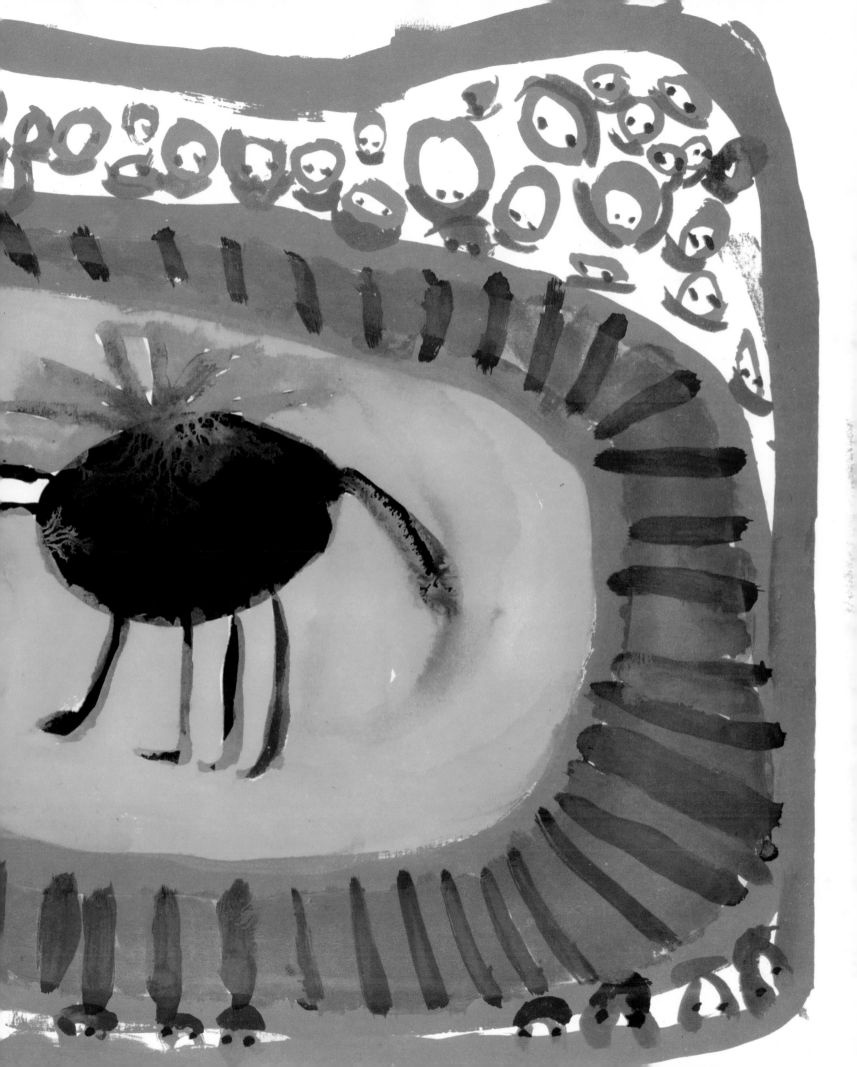

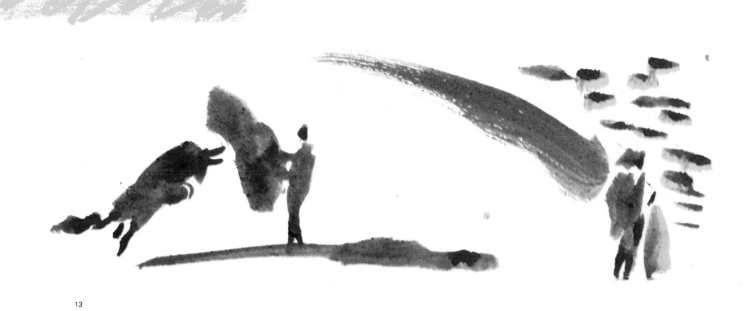

13

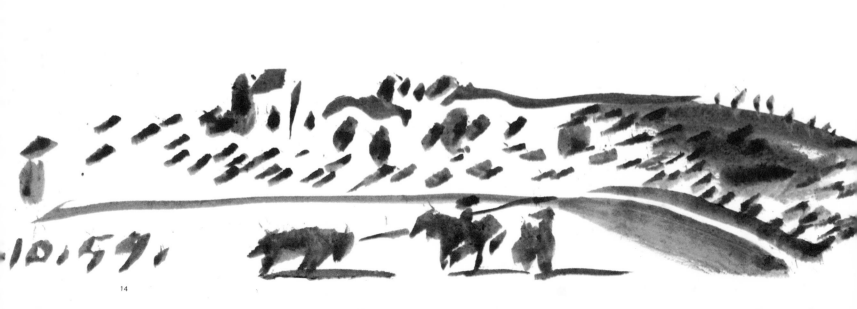

14

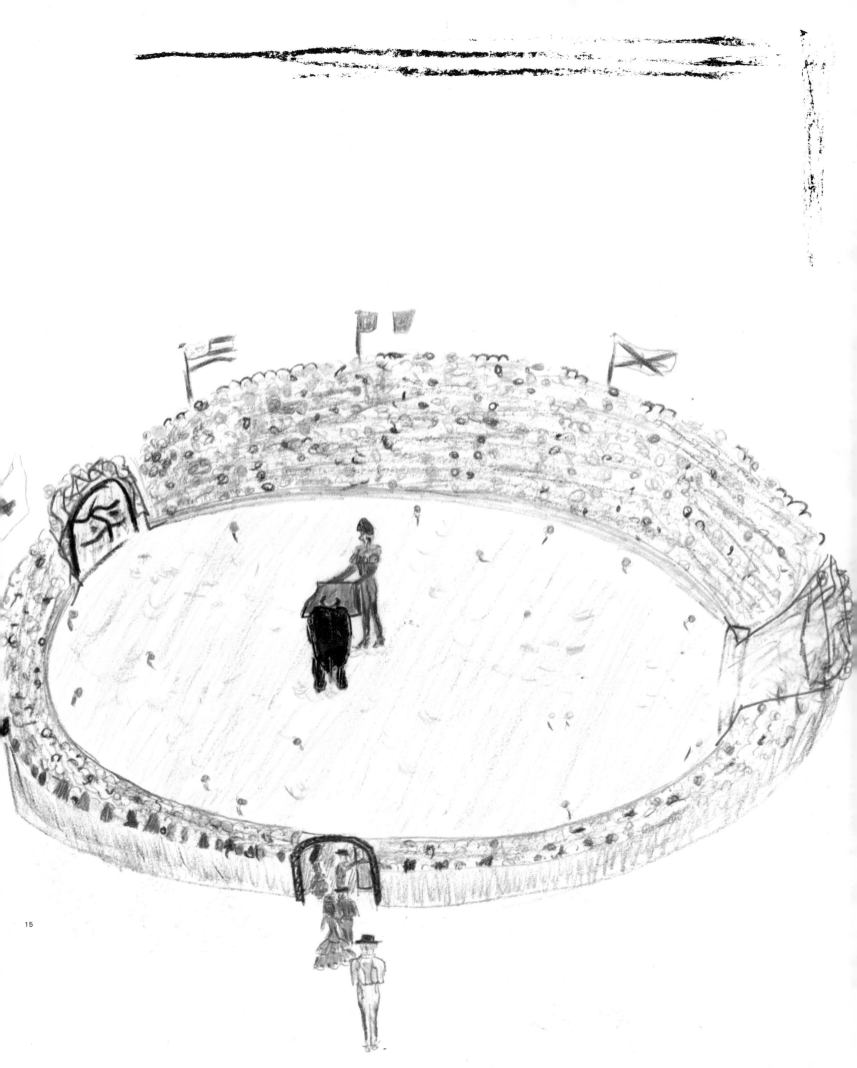

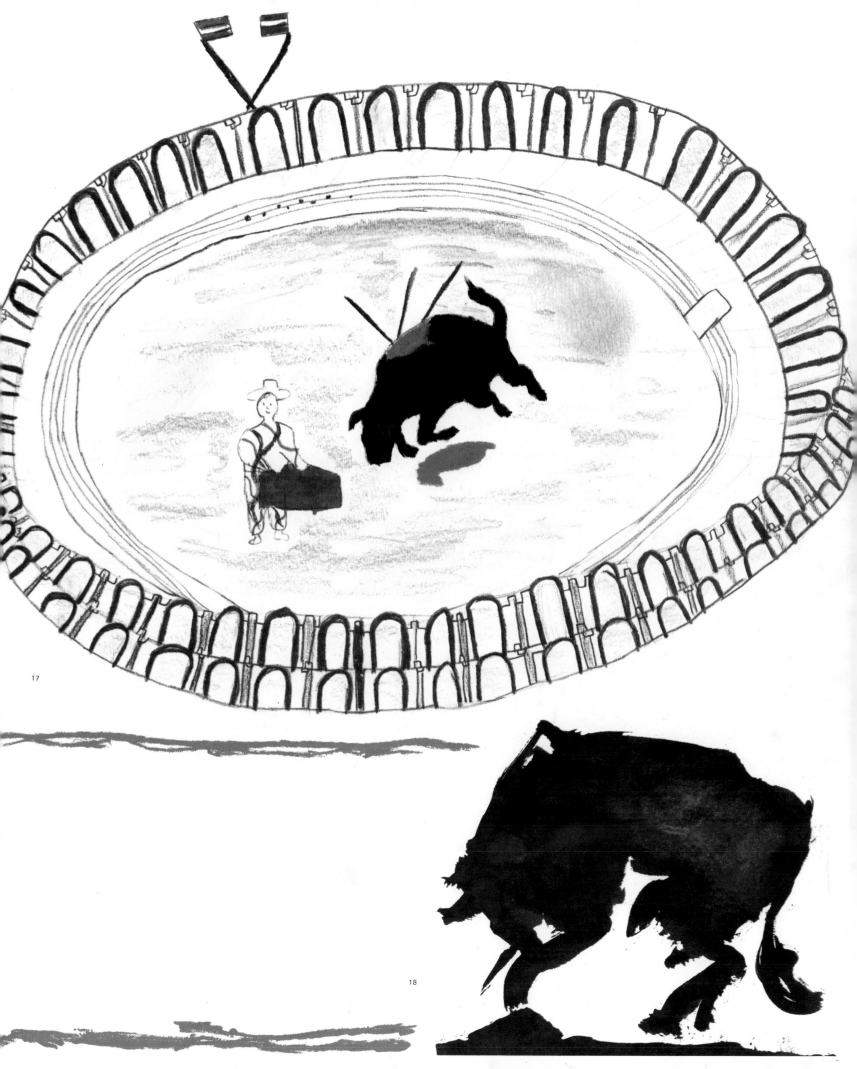

19

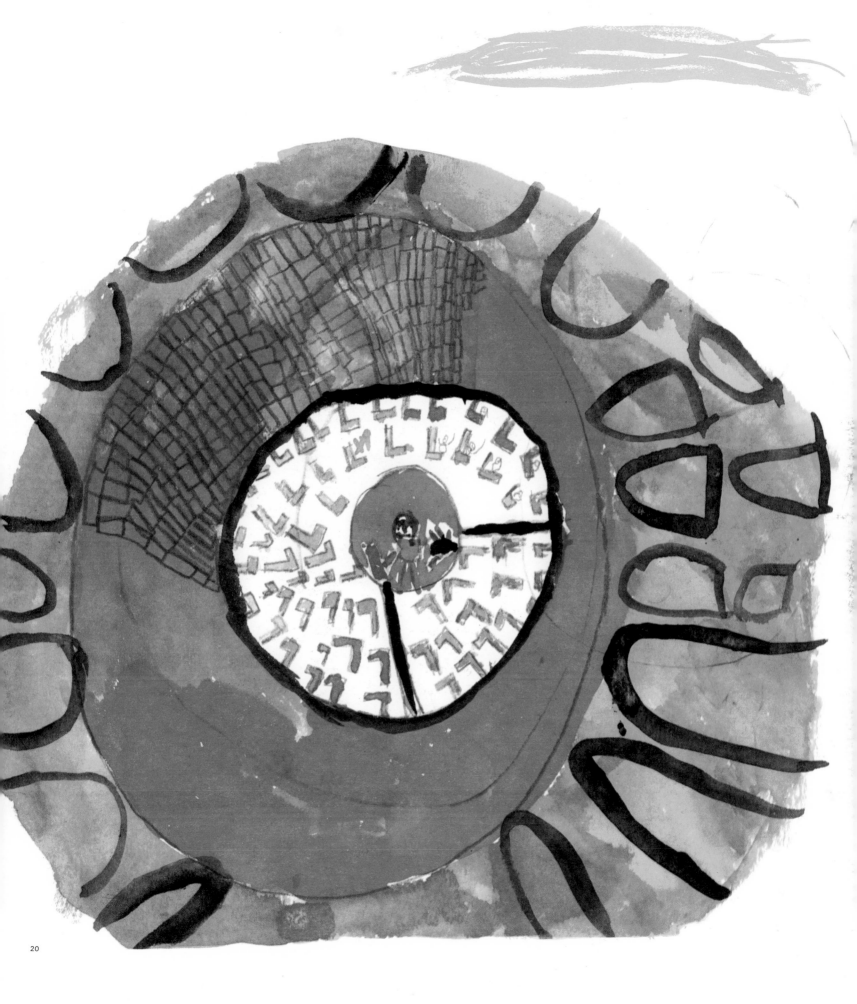

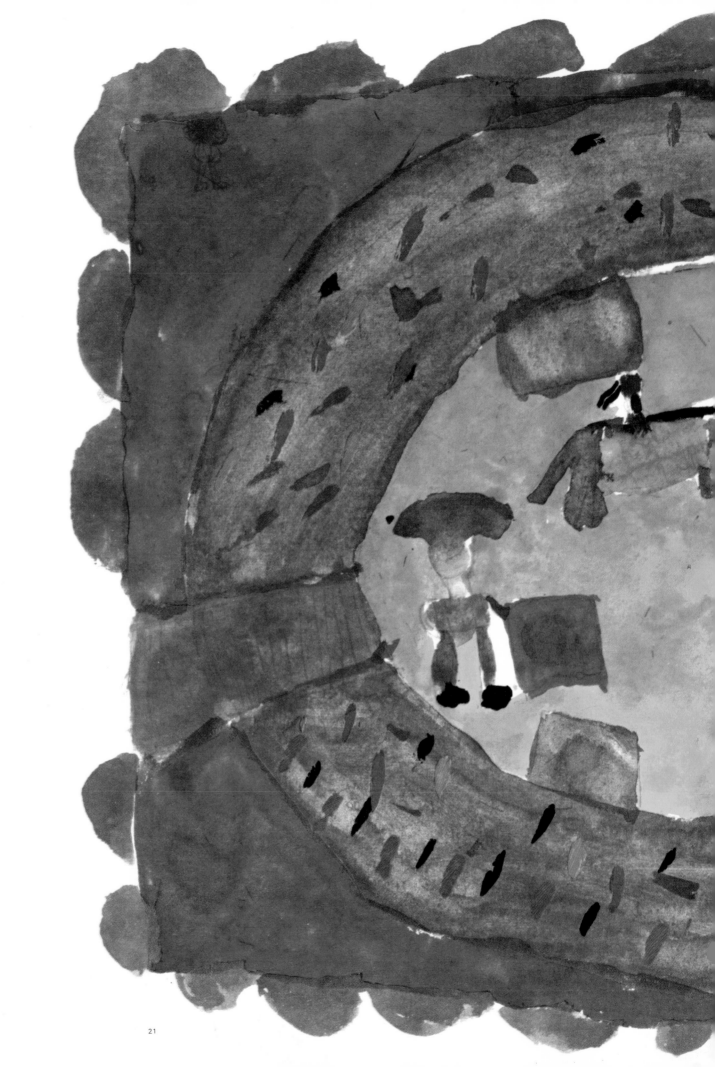

21

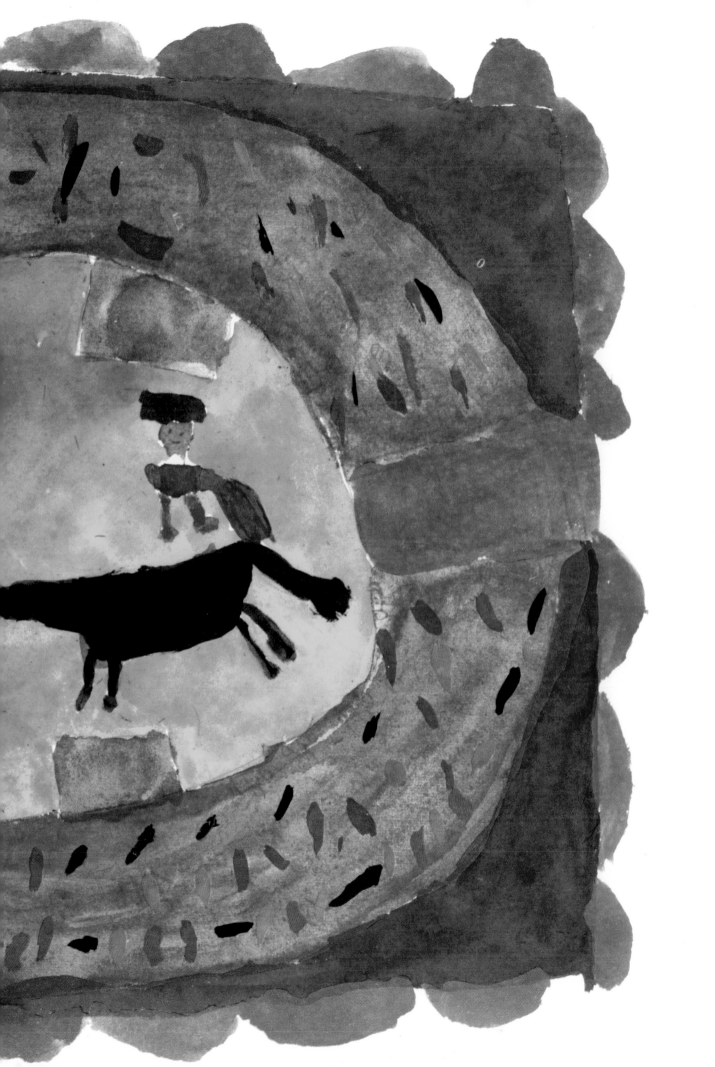

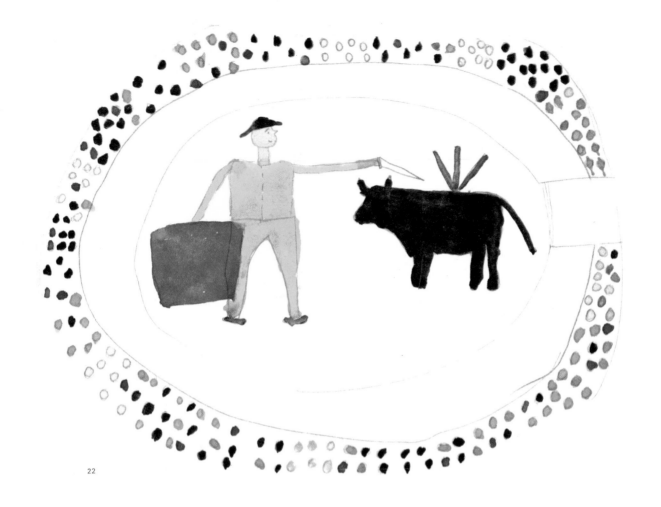

22

3.3.59. III

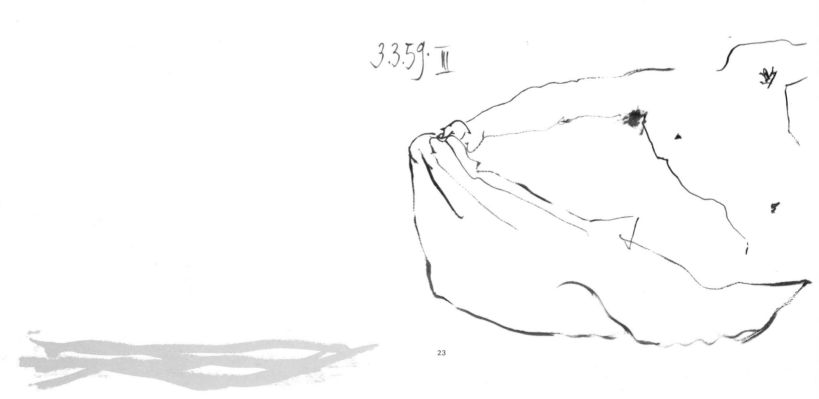

23

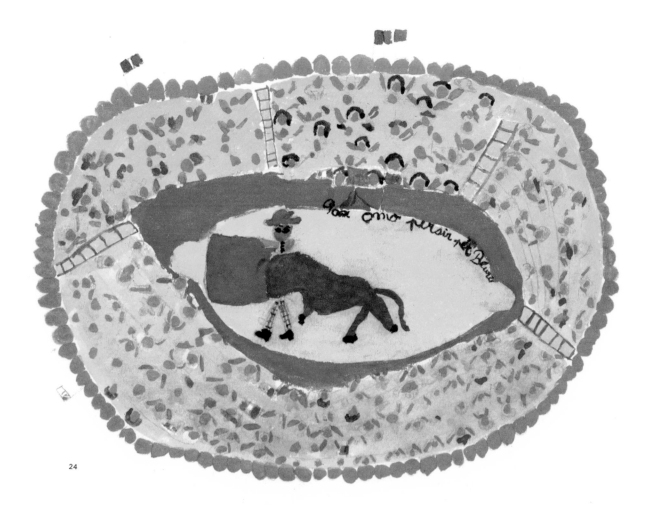

24

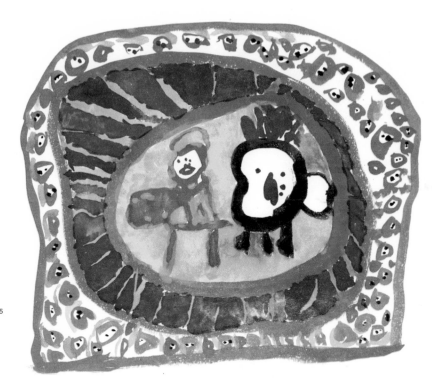

25

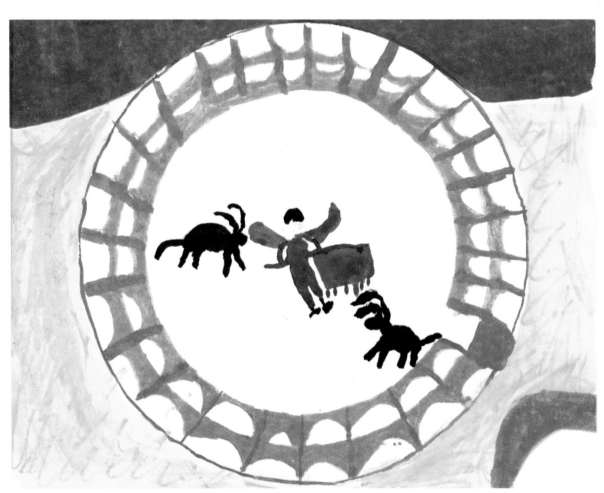

26

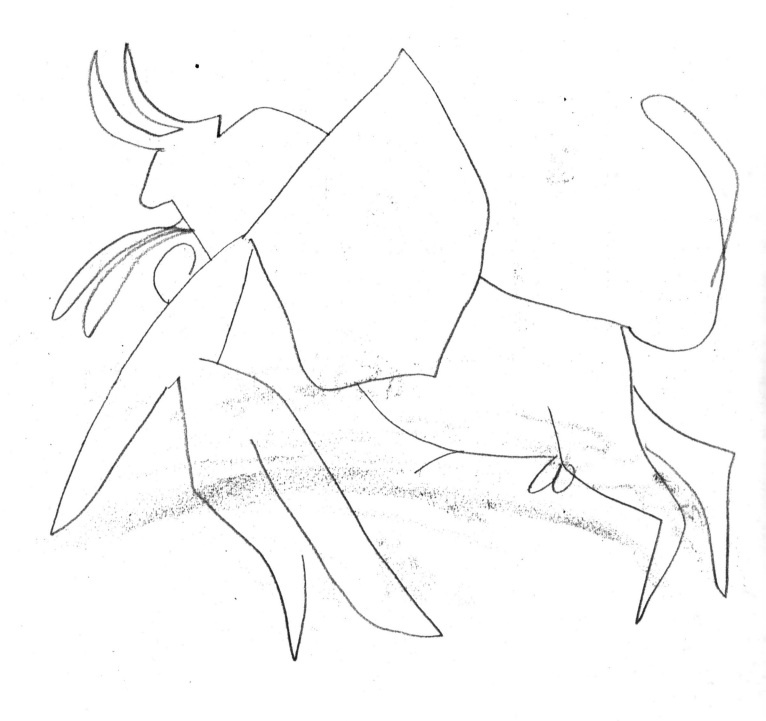

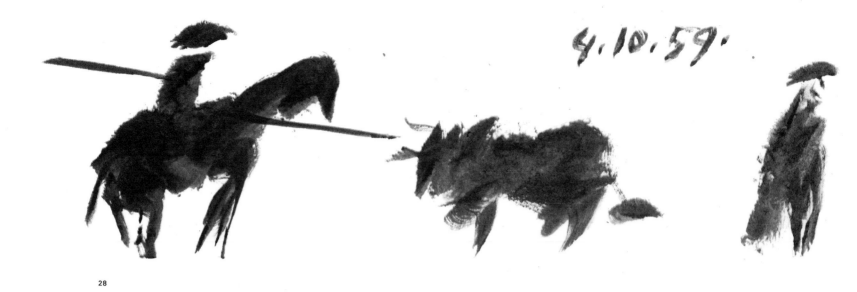

4.10.59.

28

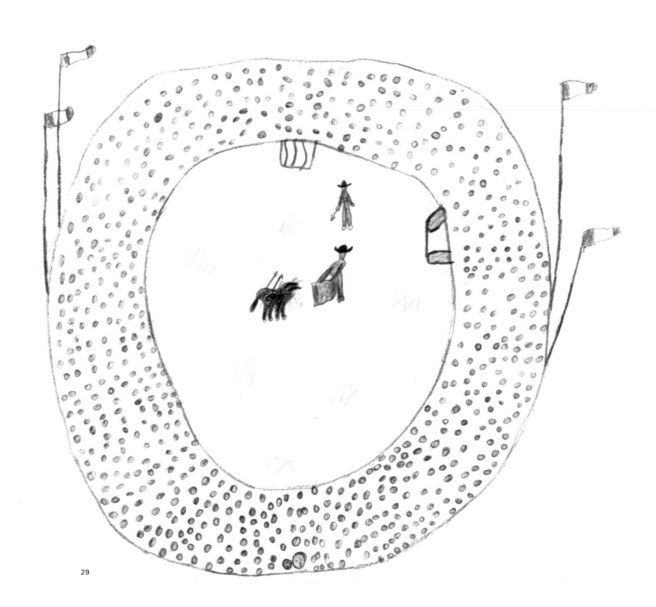

29

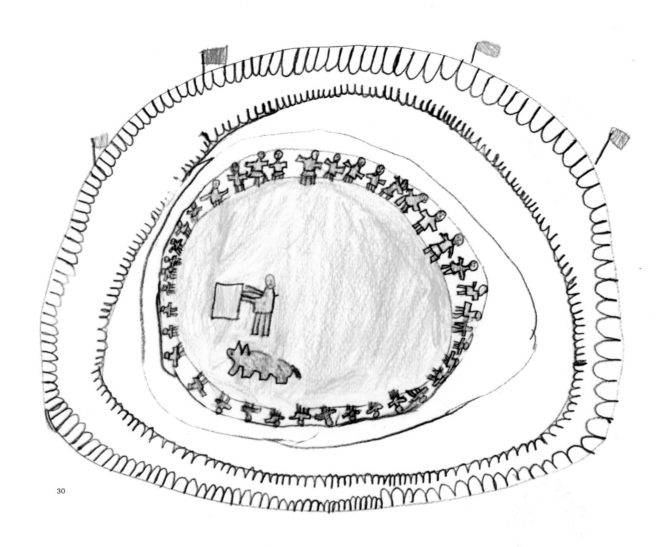

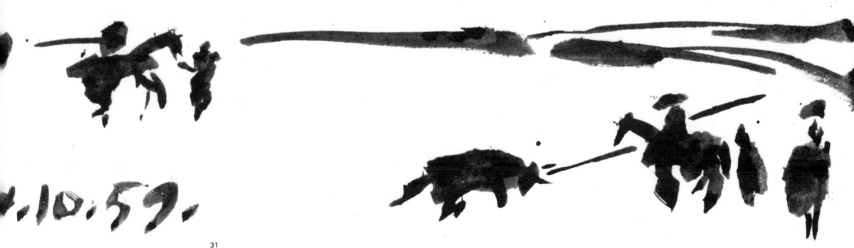

.10.59.

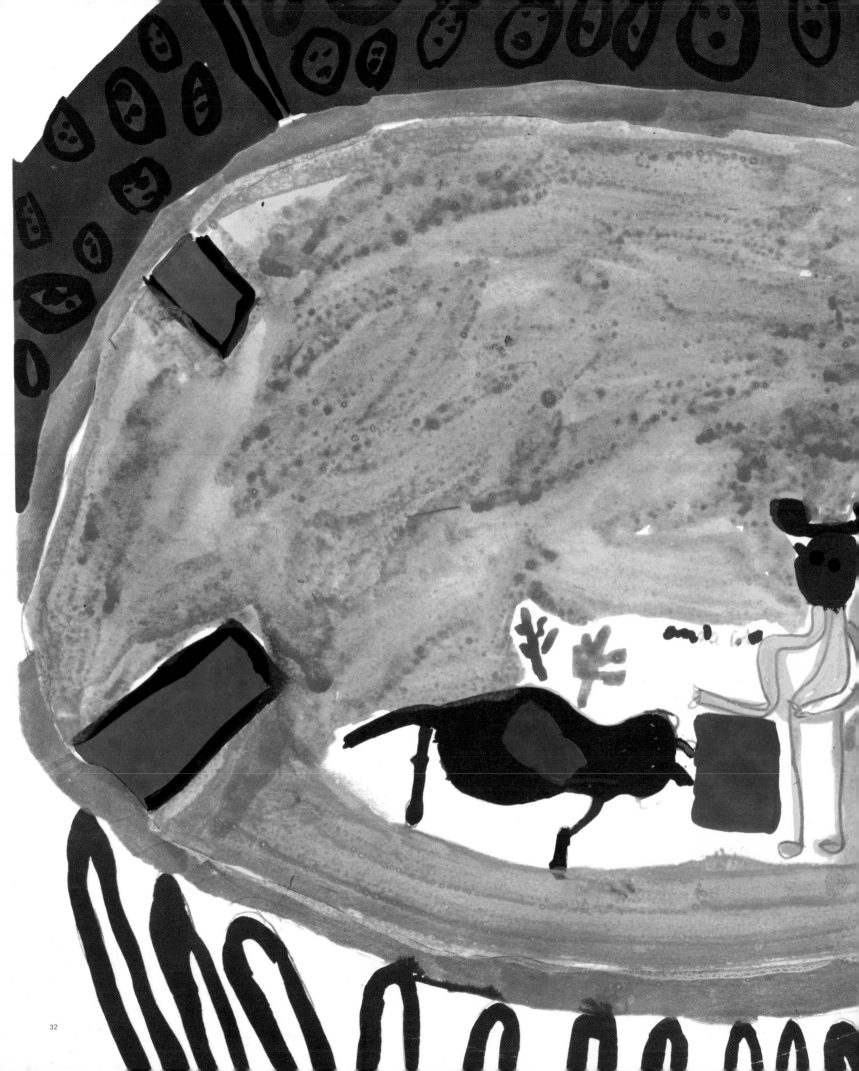

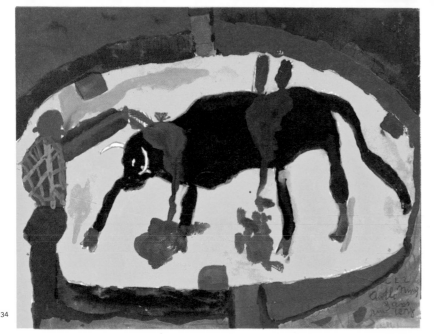

34

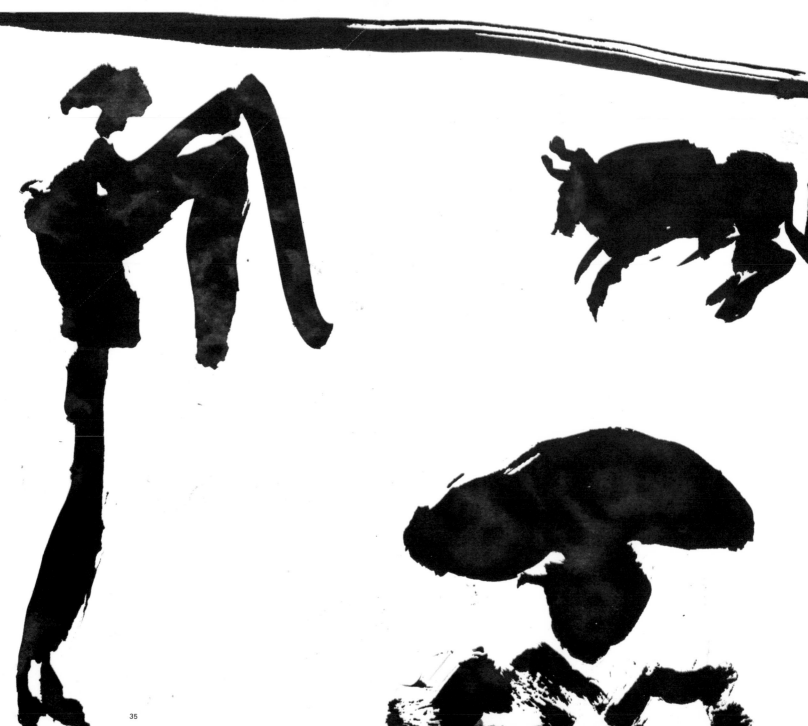

35

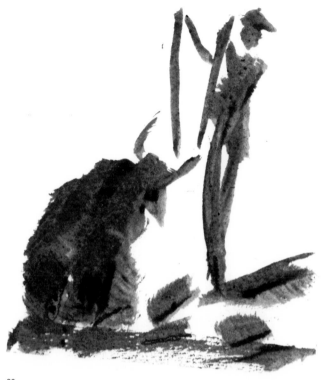

36

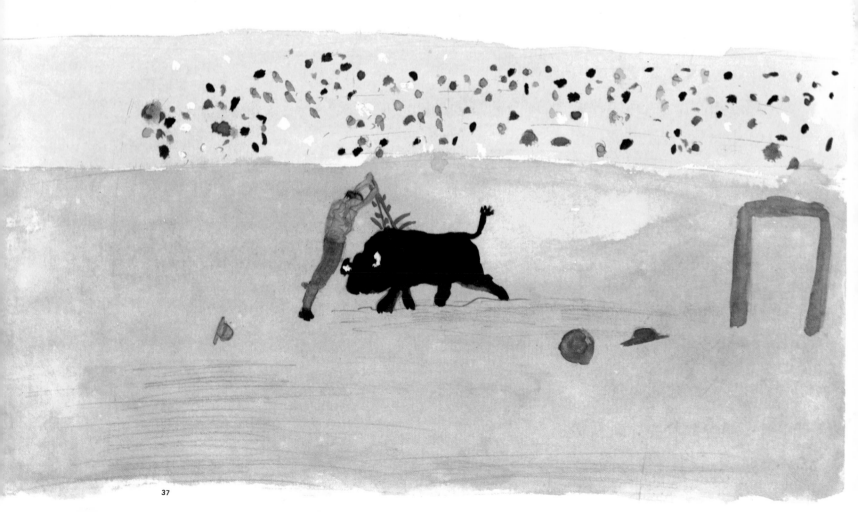

3.6.57.
VIII

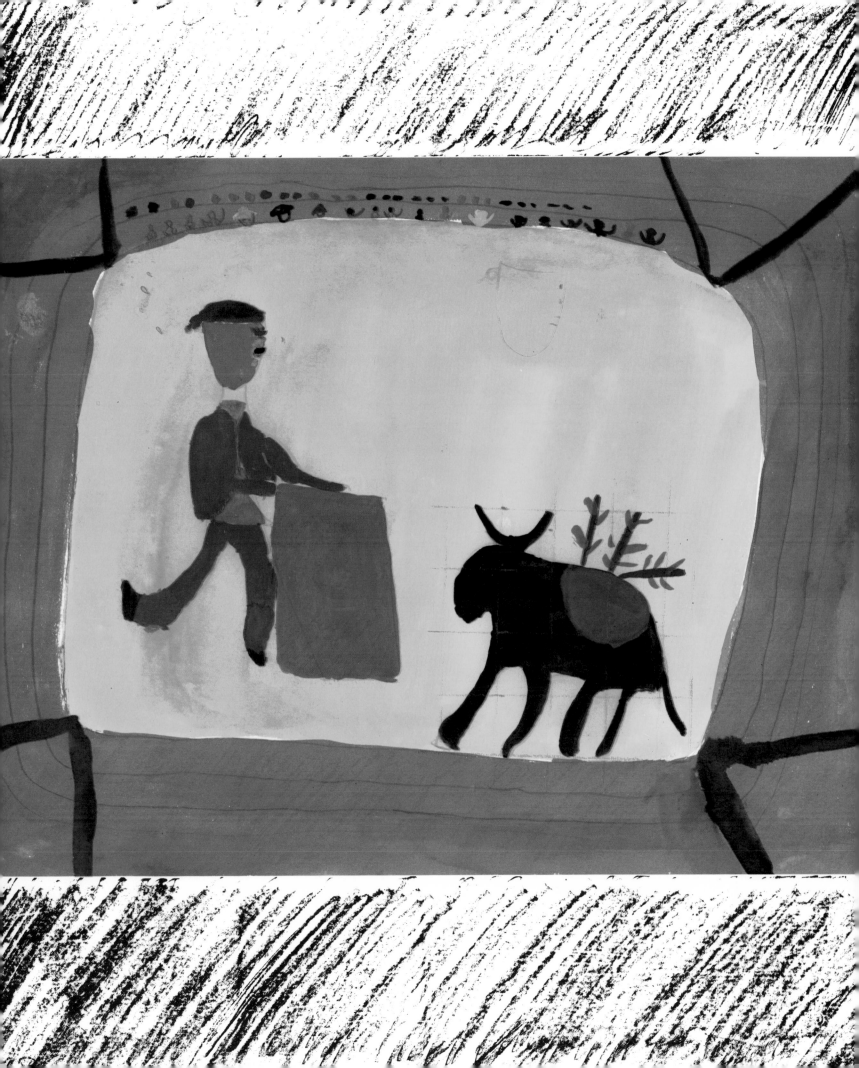

13.6.57
VI

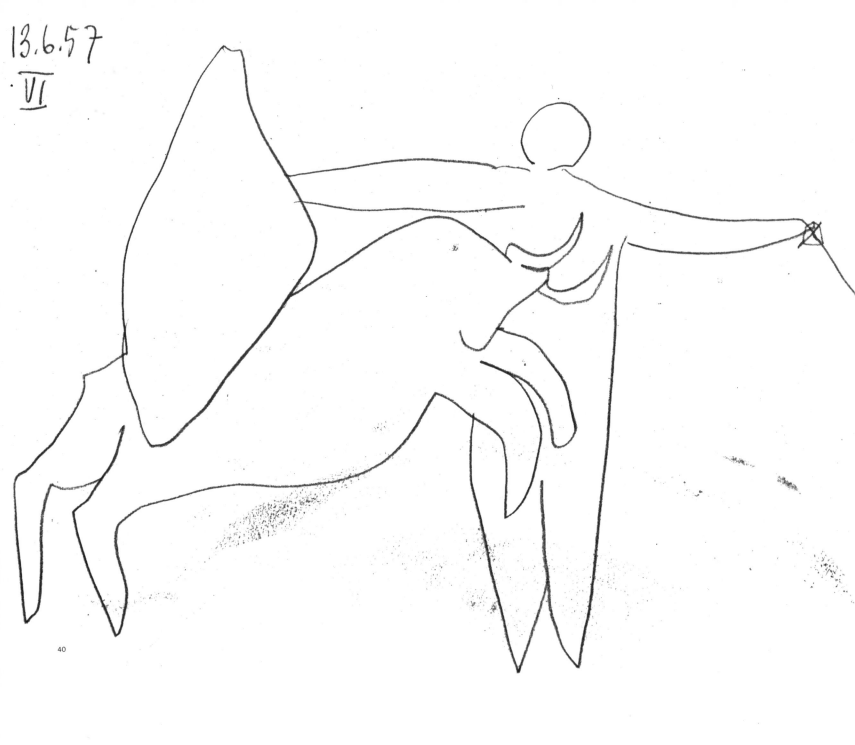

40

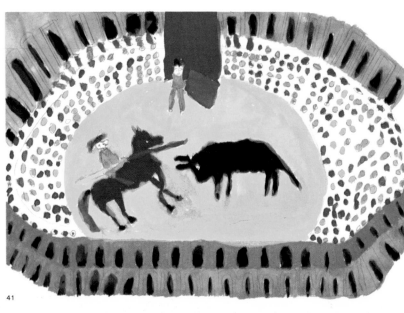

41

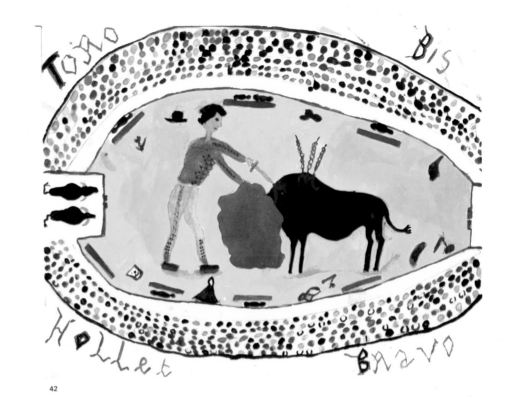

42

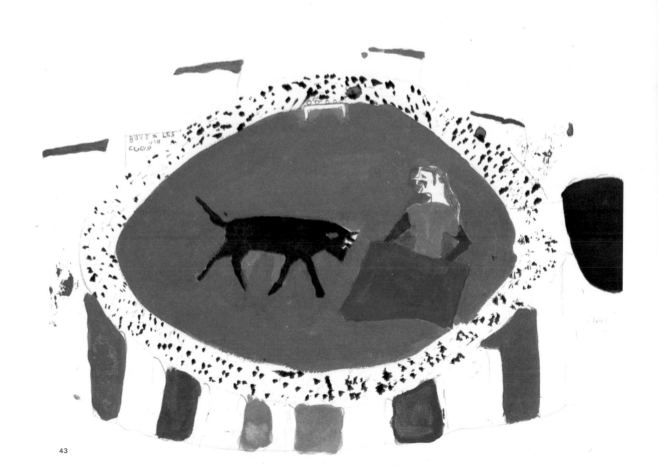

43

2.3.59·XI

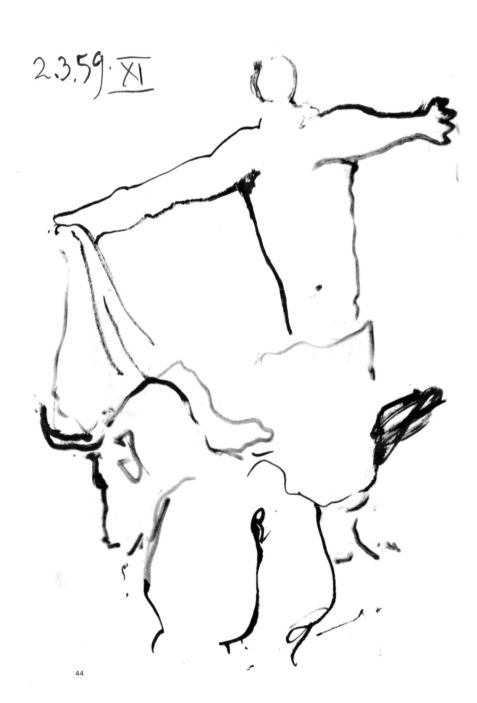

44

45

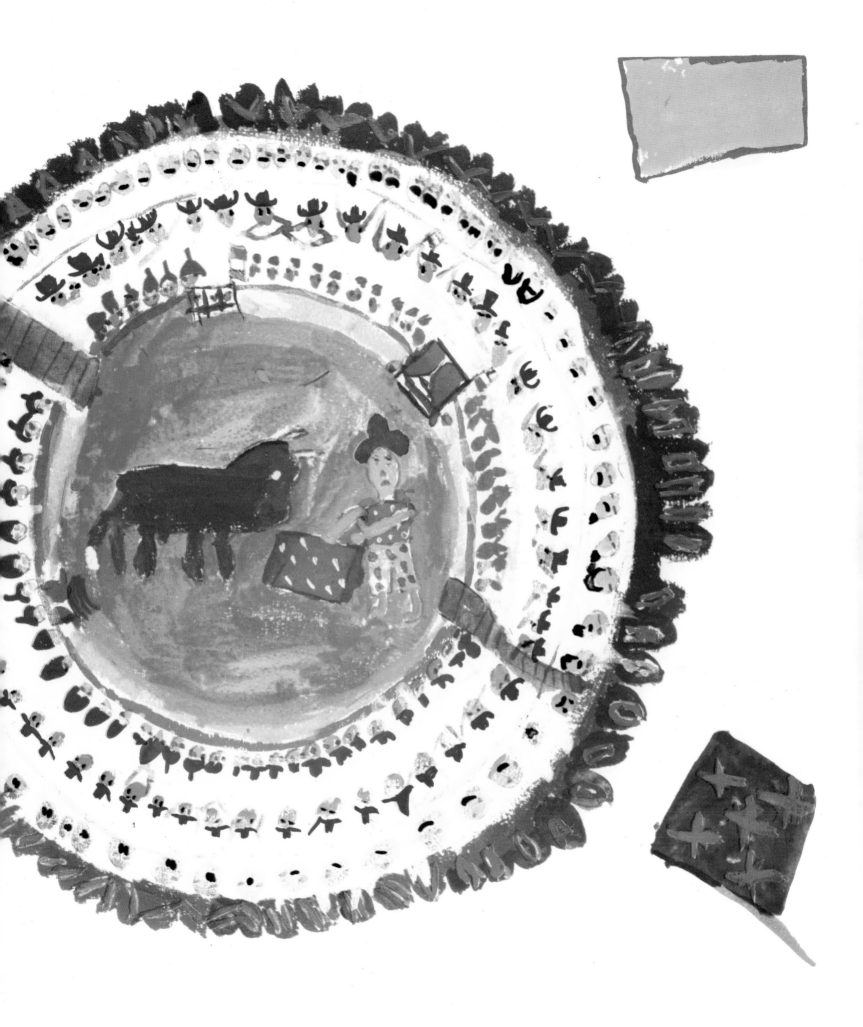

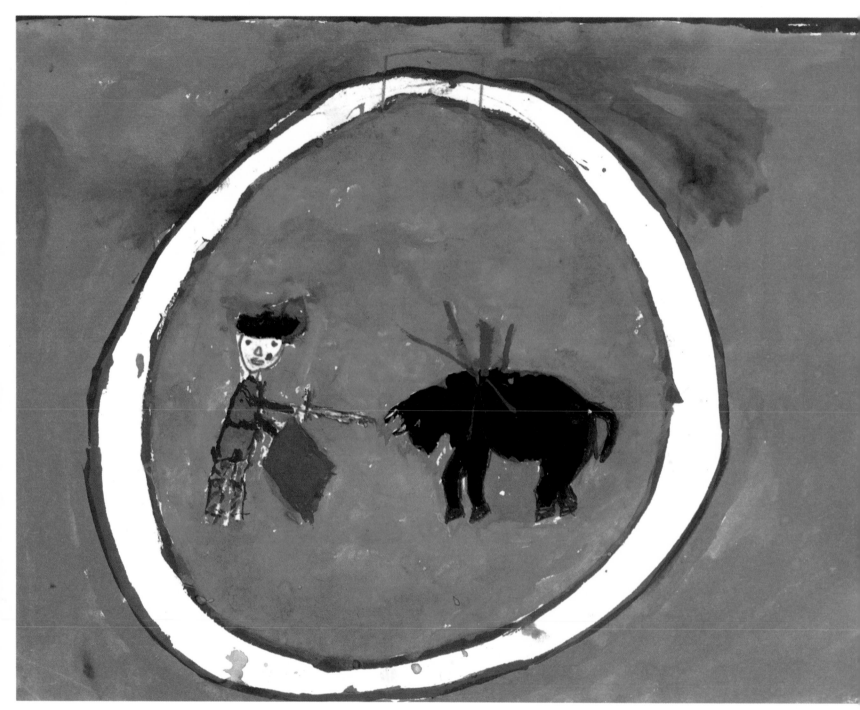

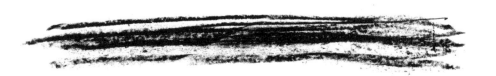

47

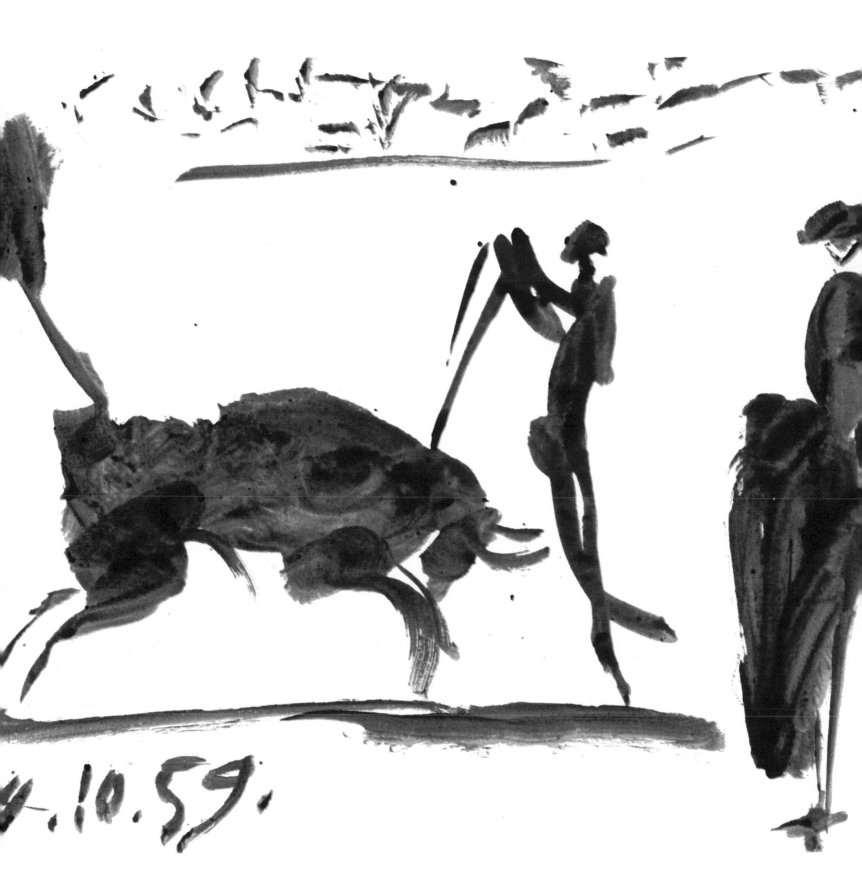

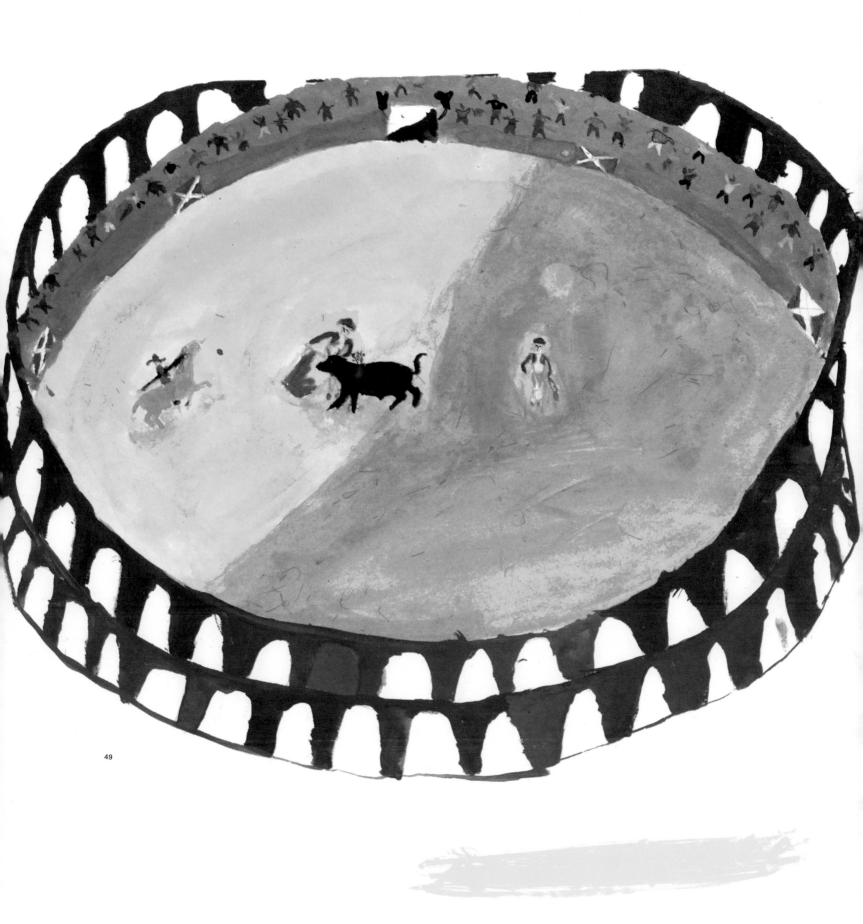

49

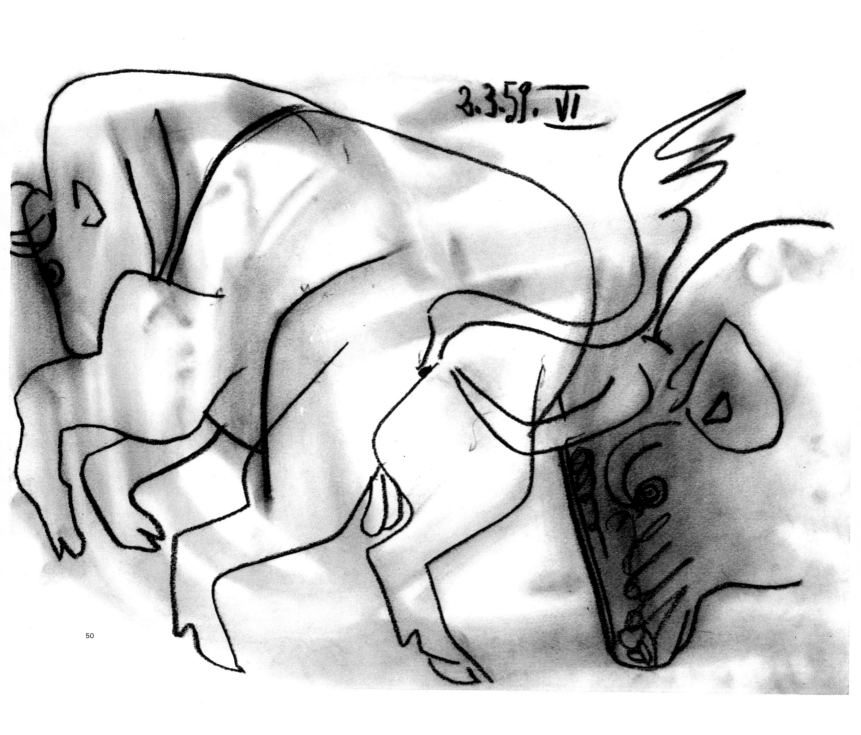

50

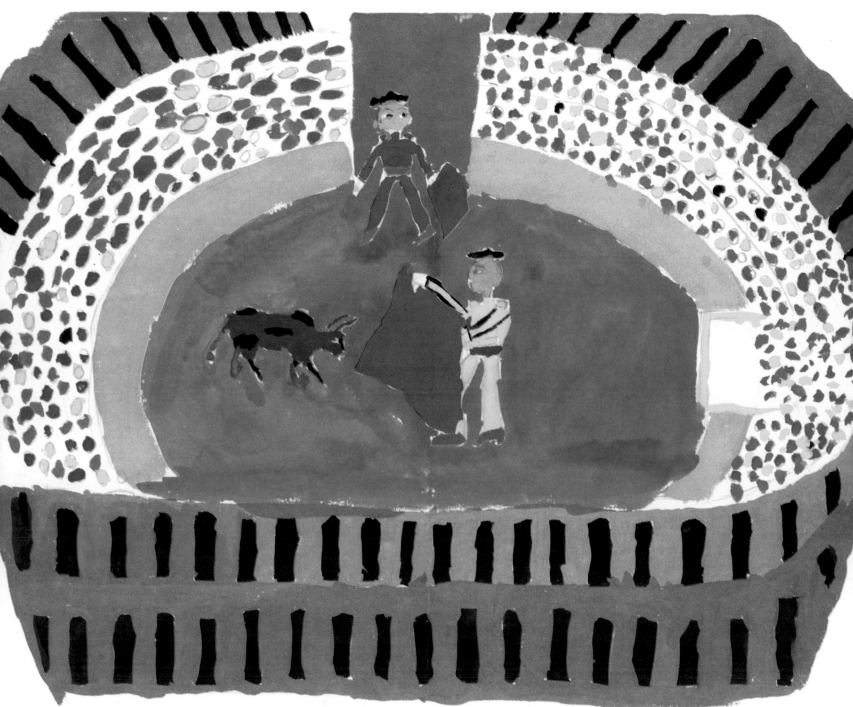

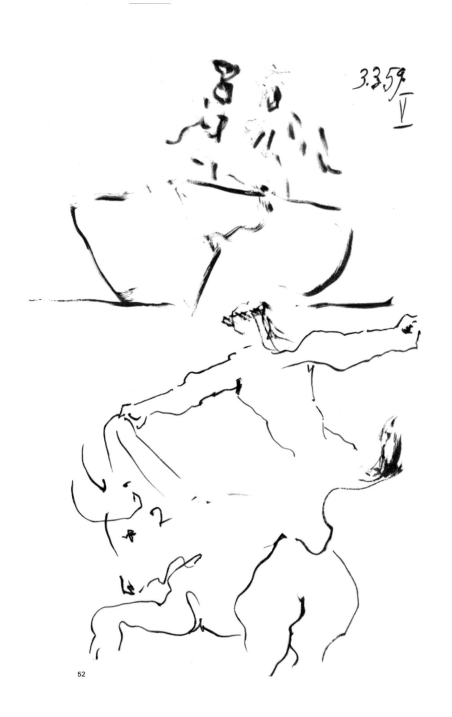

3.3.59
V

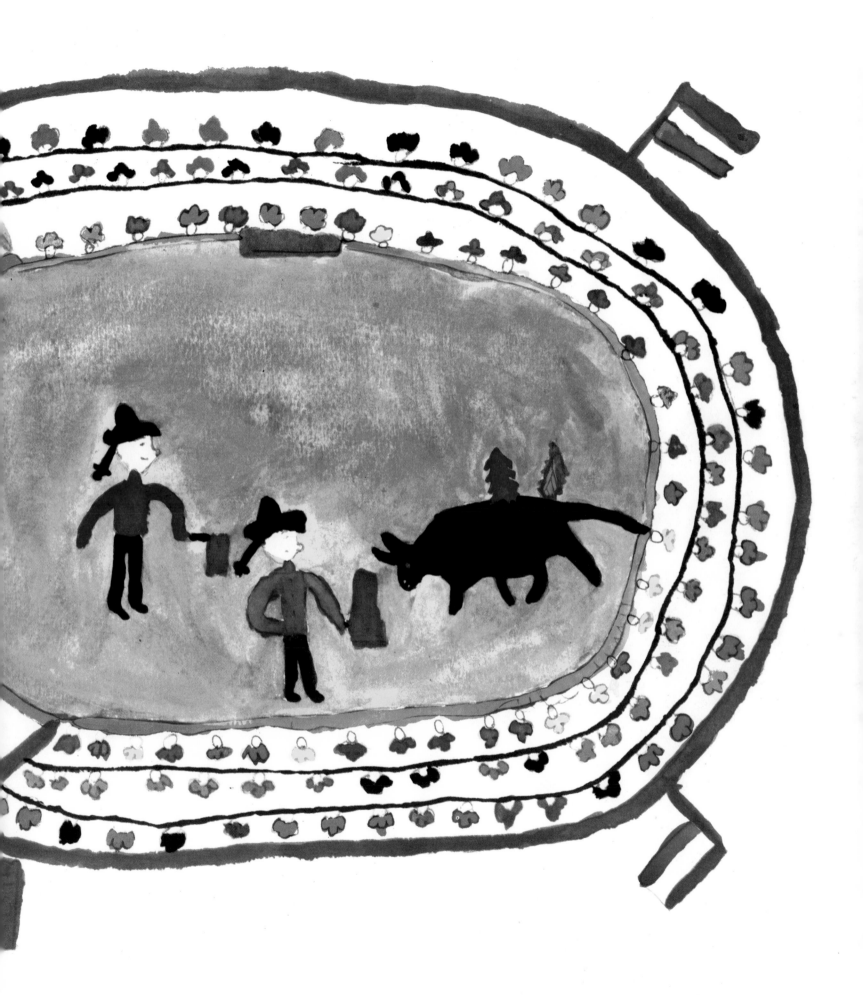

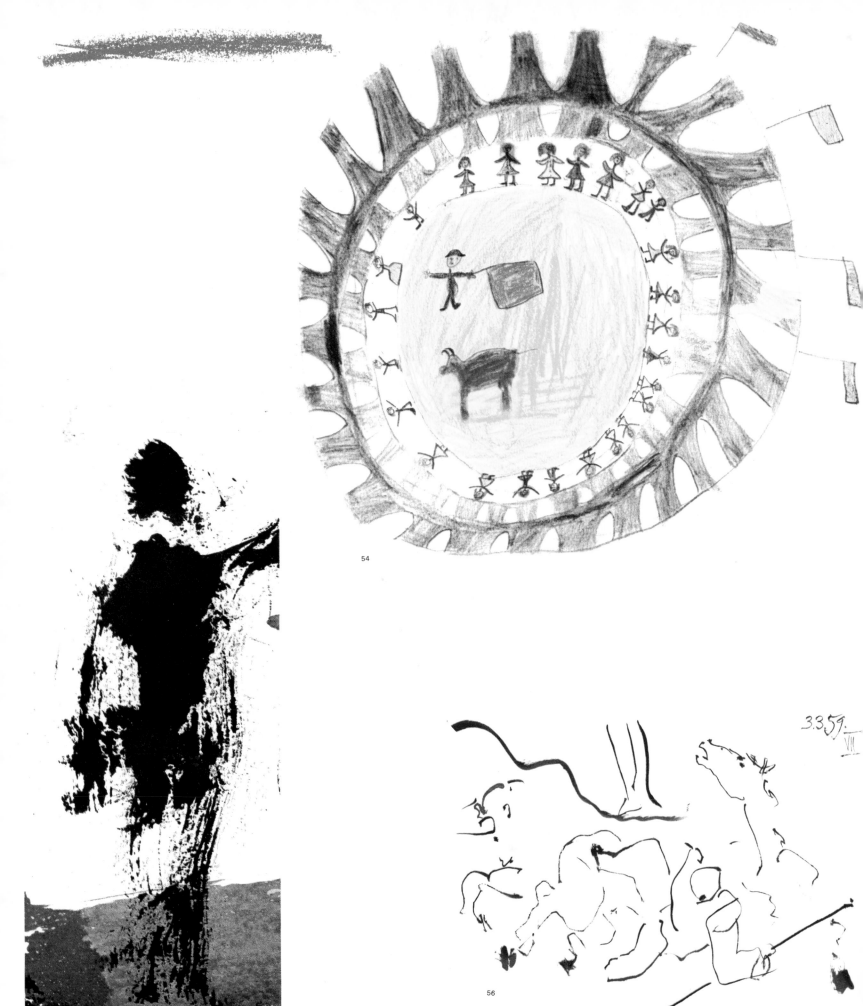

54

55

56

3.3.59.
VII

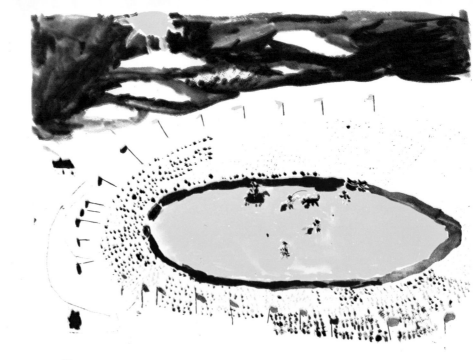

57

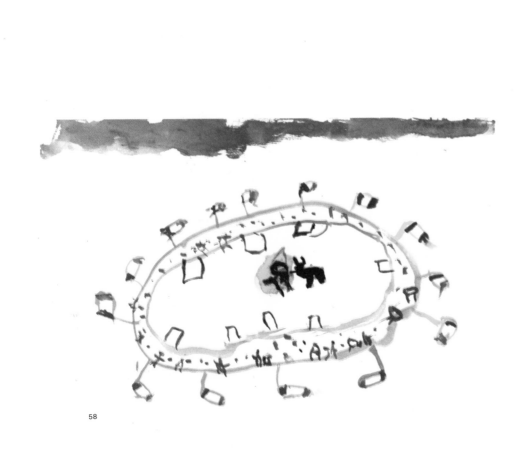

58

59

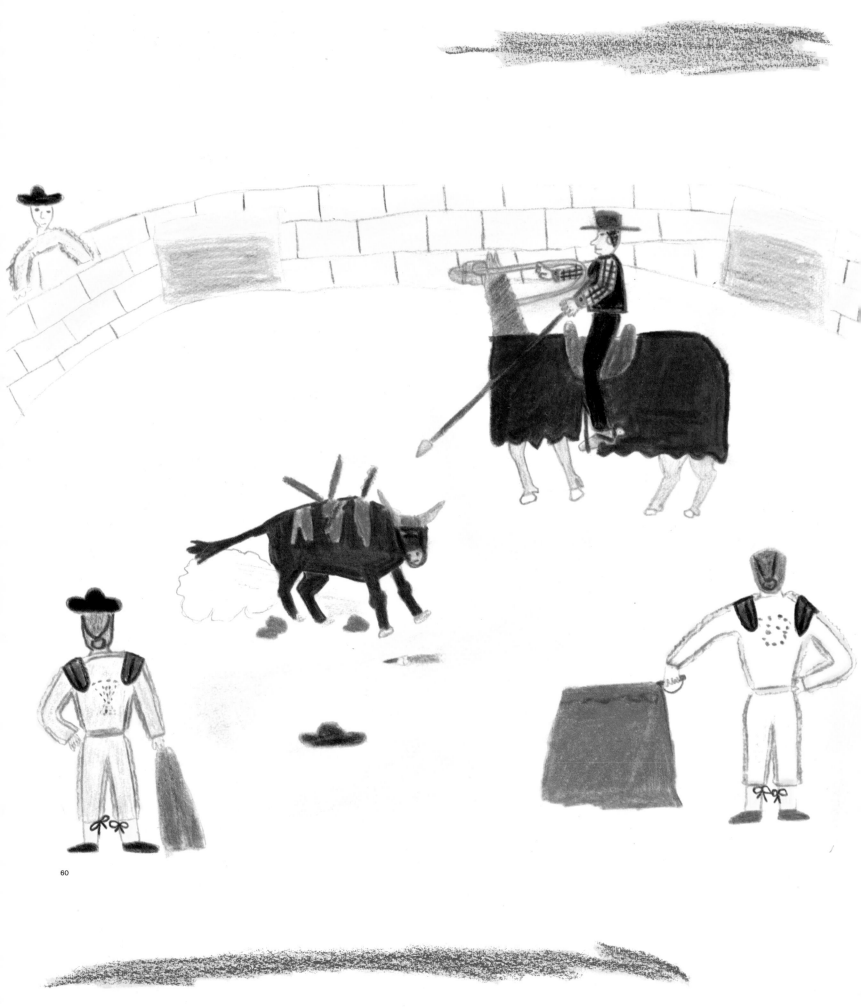

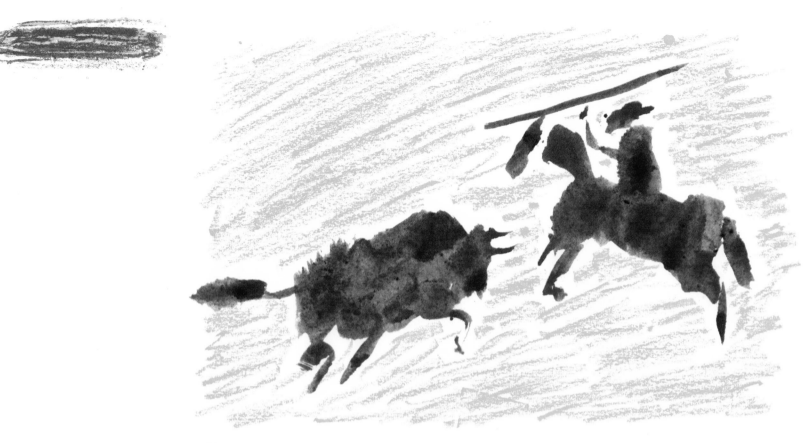

61

10.54.

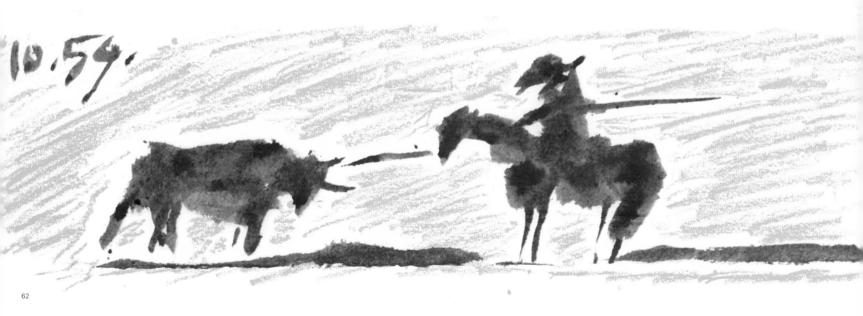

62

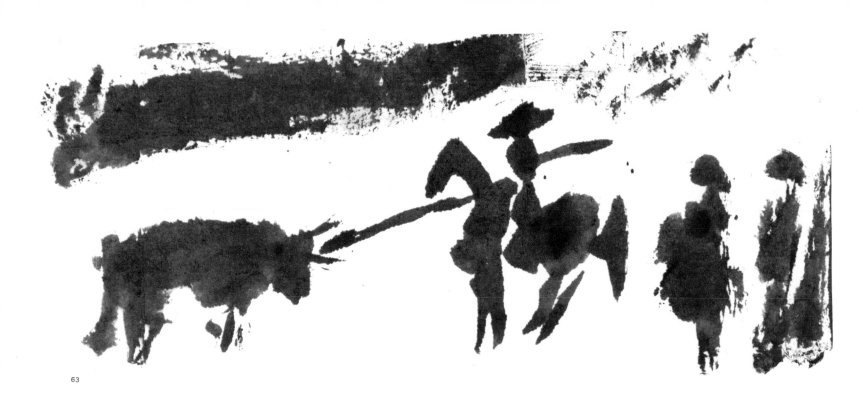

63

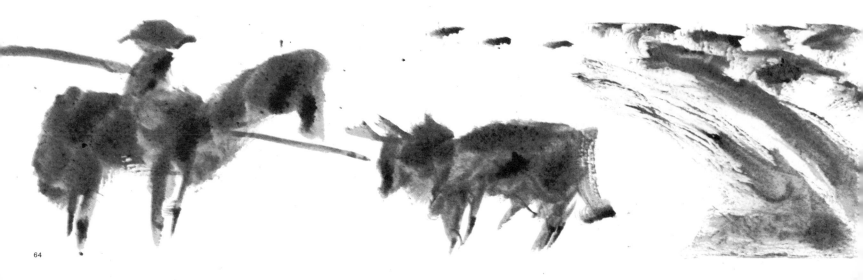

64

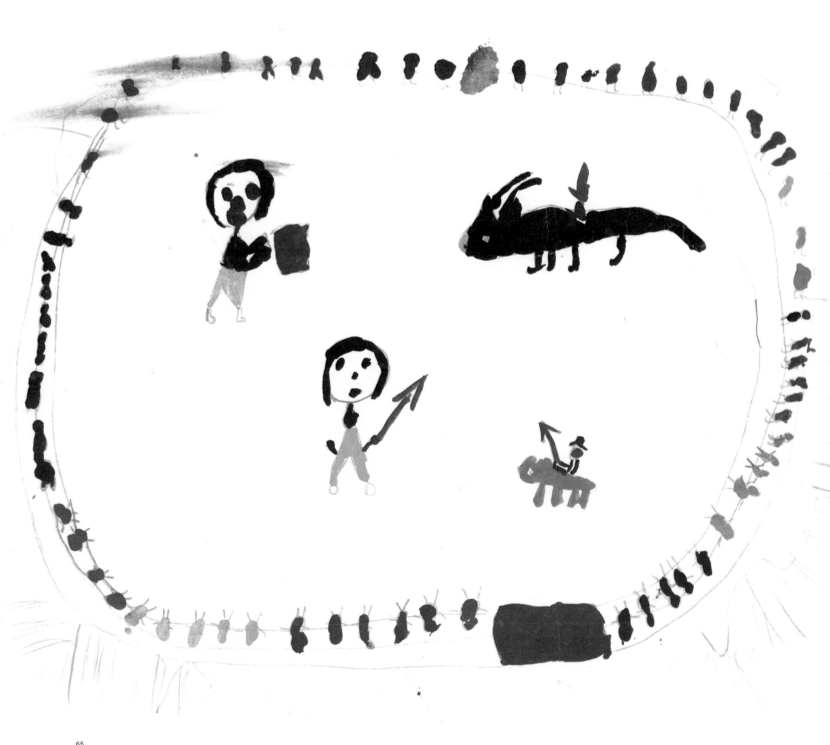

3.3.59.
I

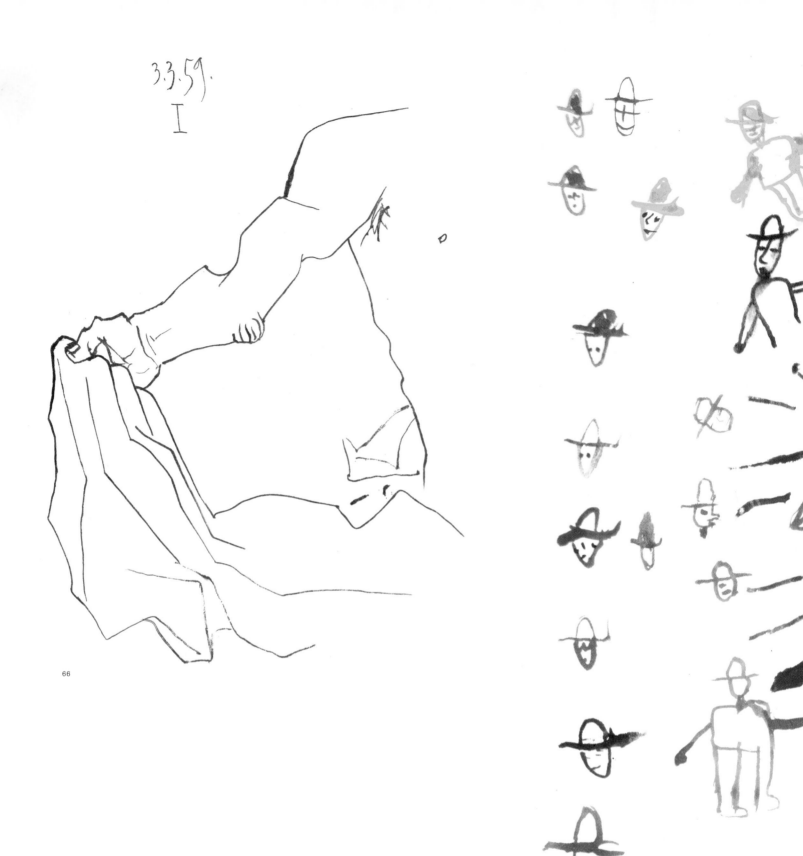

66

67

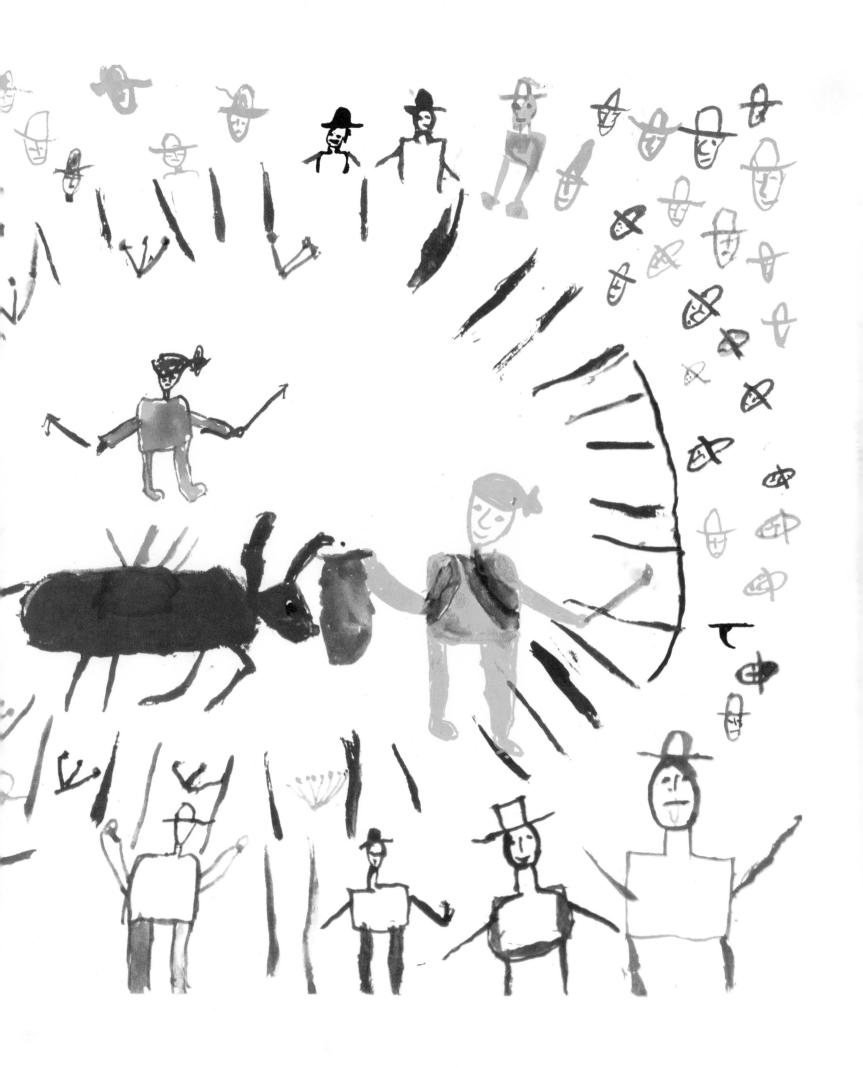

3.3.59.II

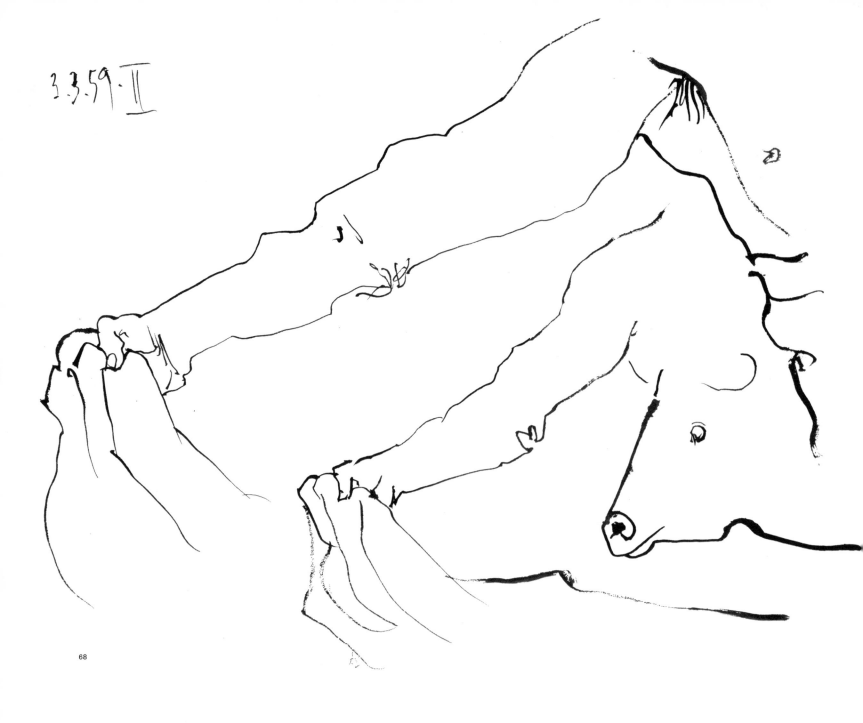

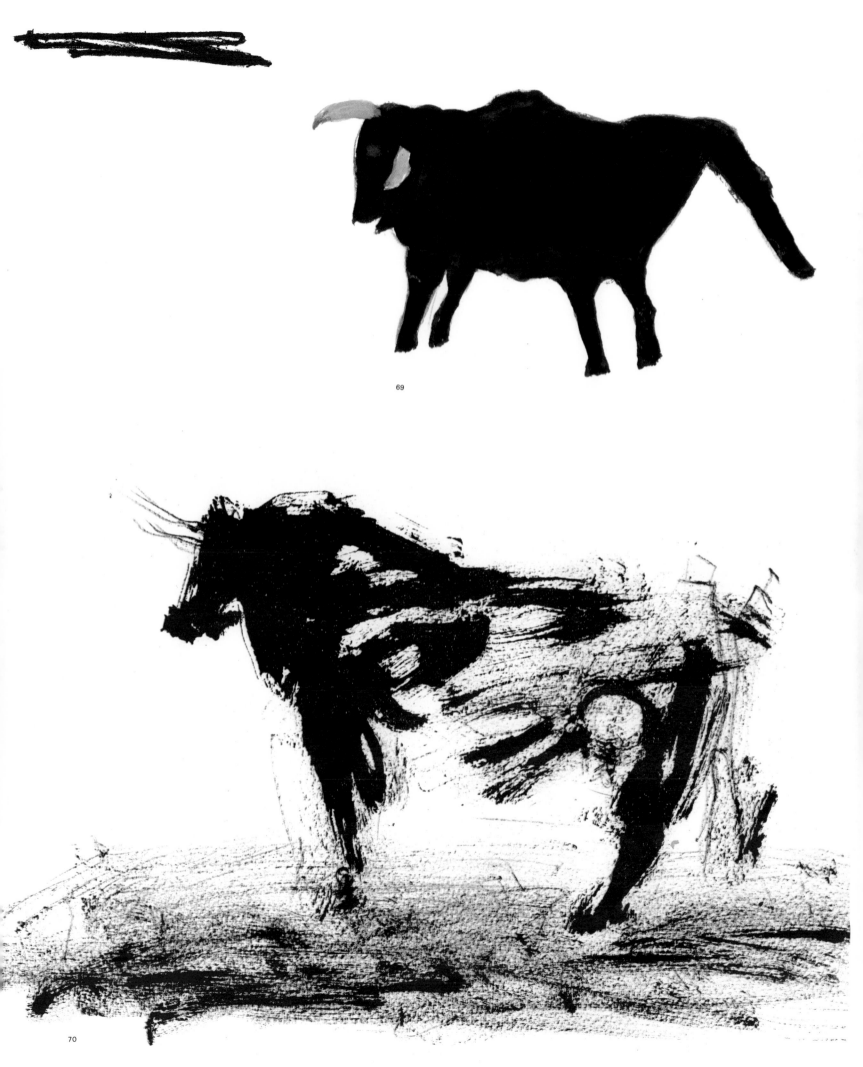

69

70

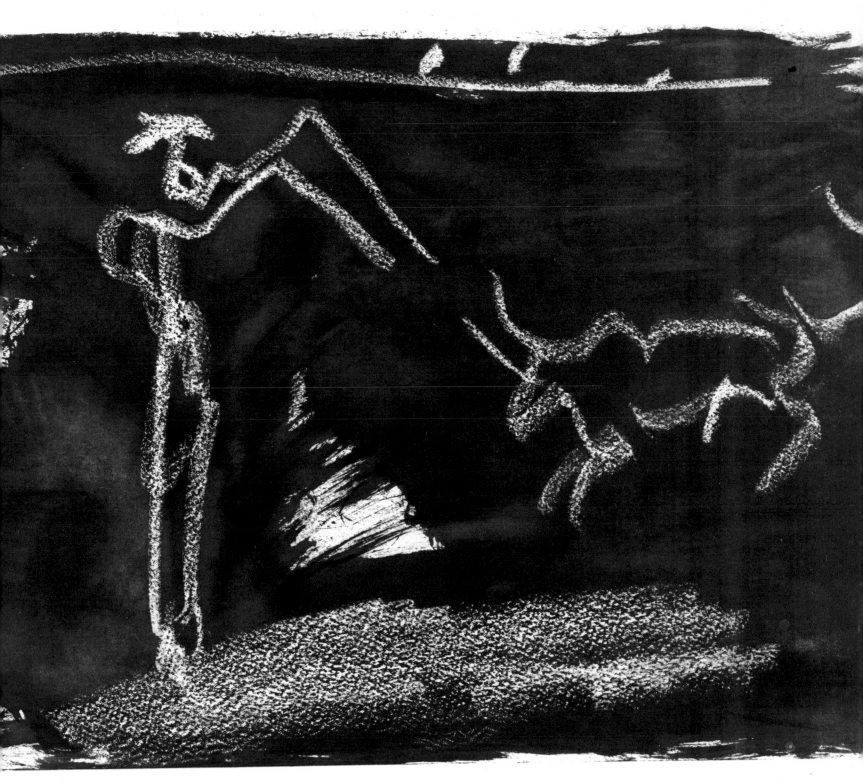

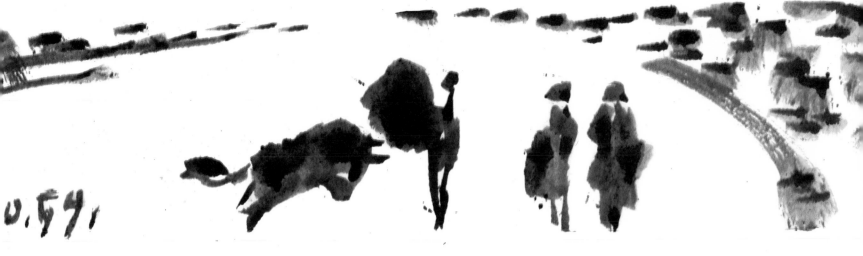

73

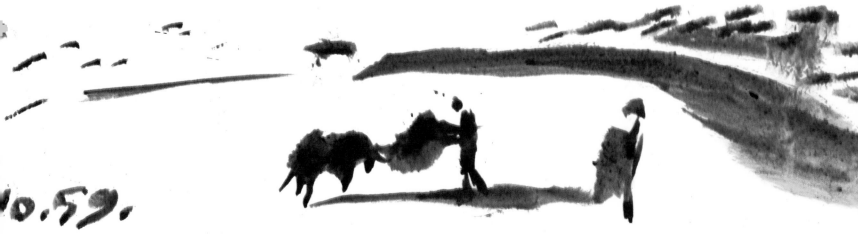

74

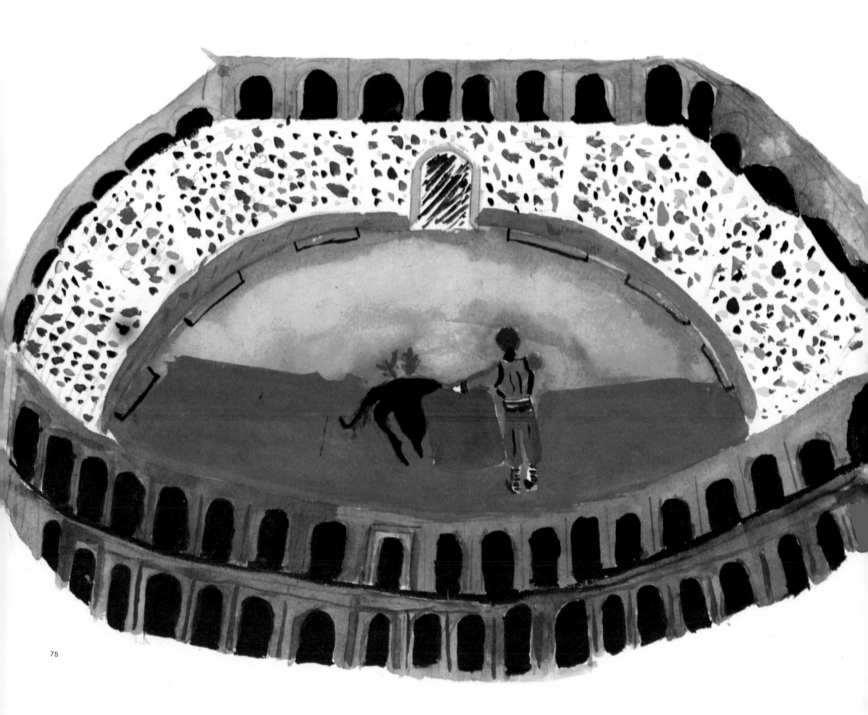

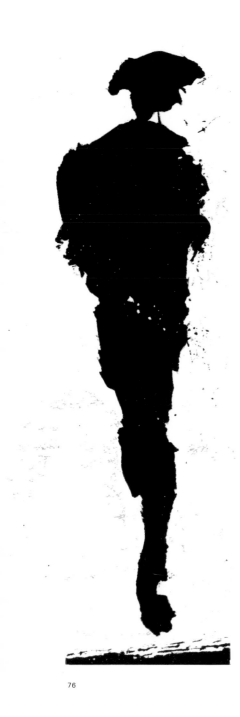

76

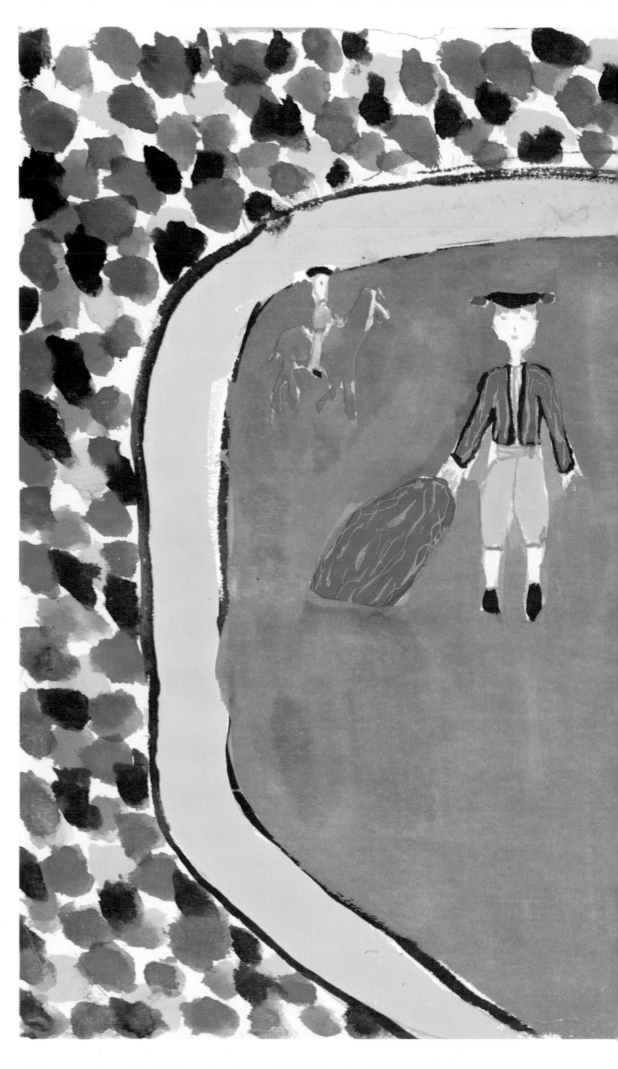

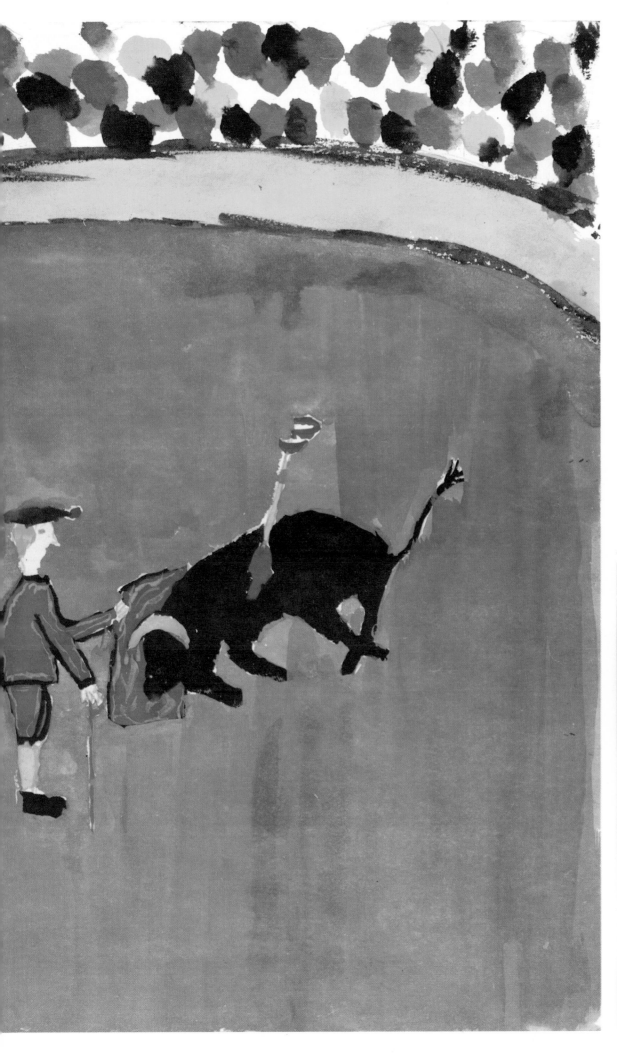
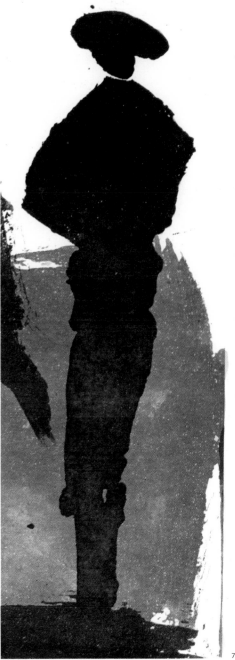

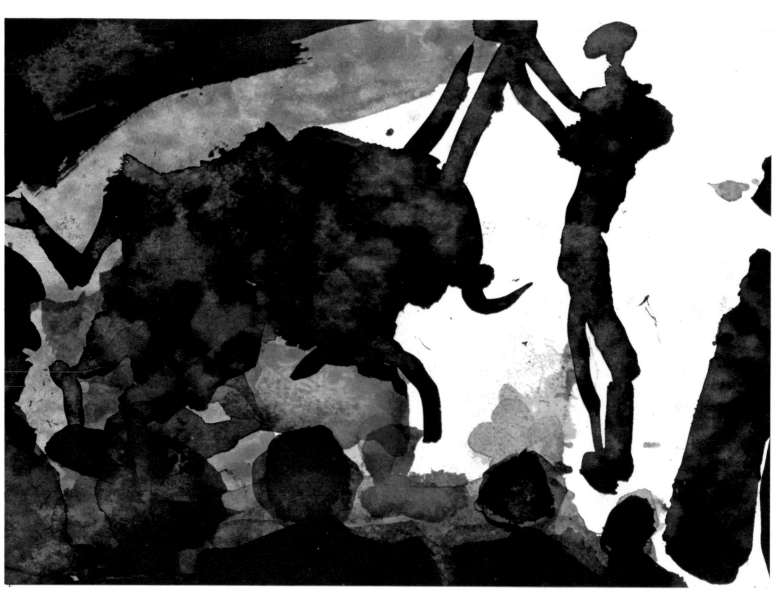

79

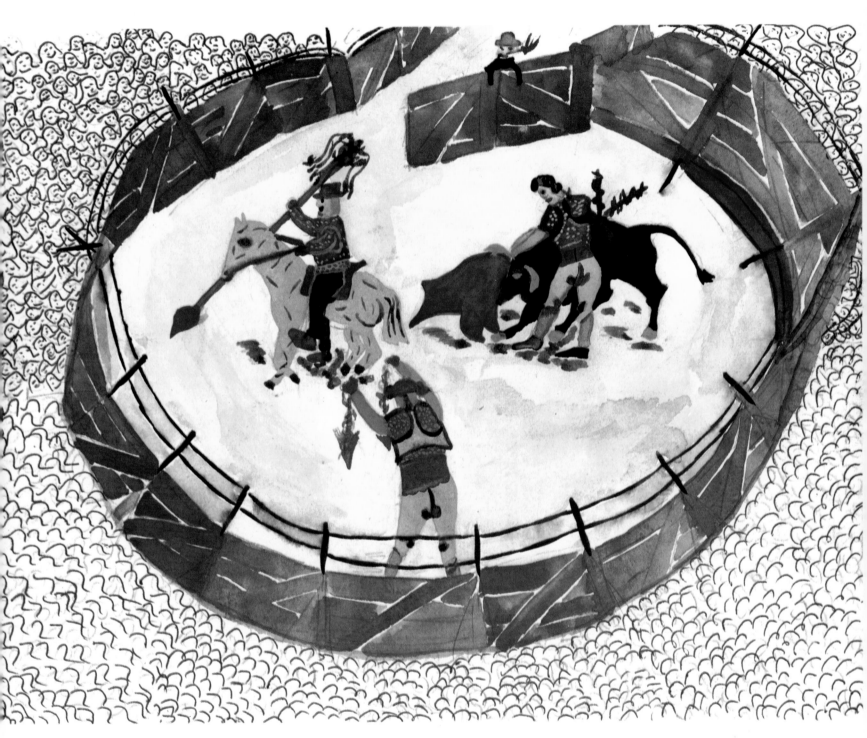

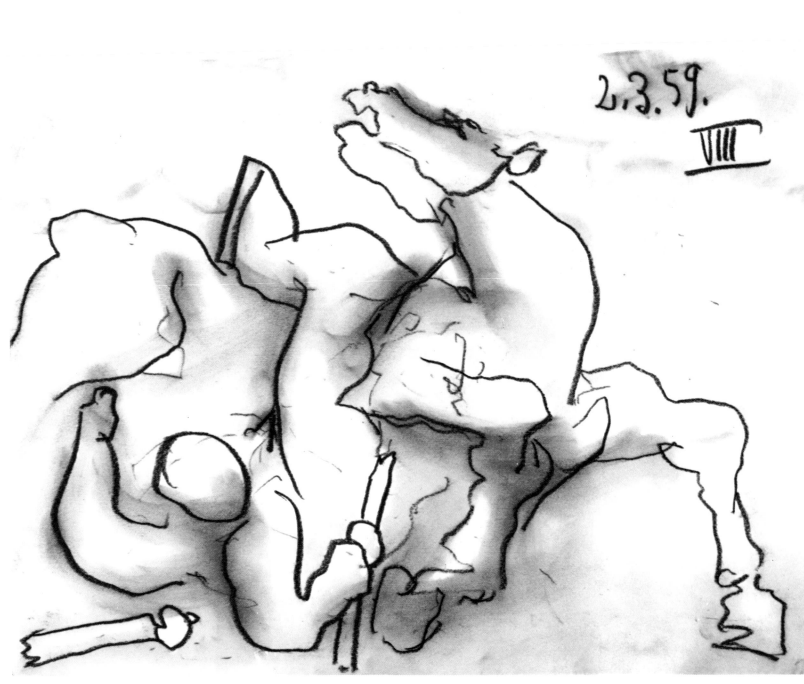

2.3.59.

VIII

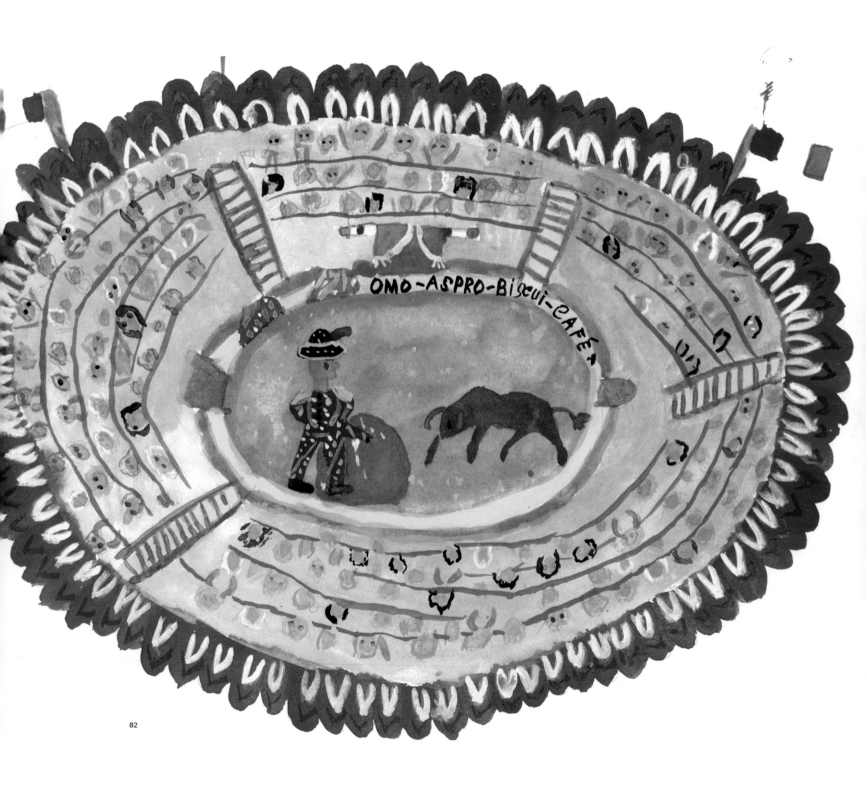

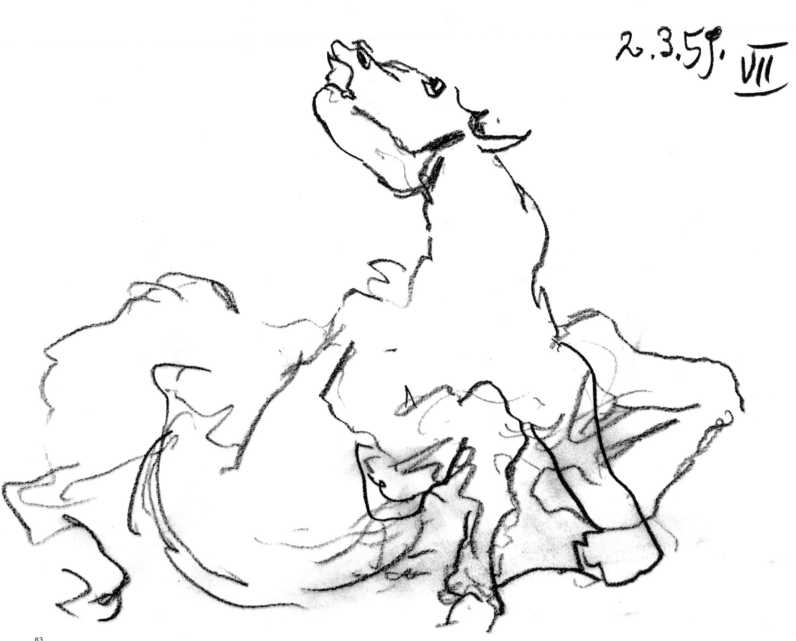

2.3.5). VII

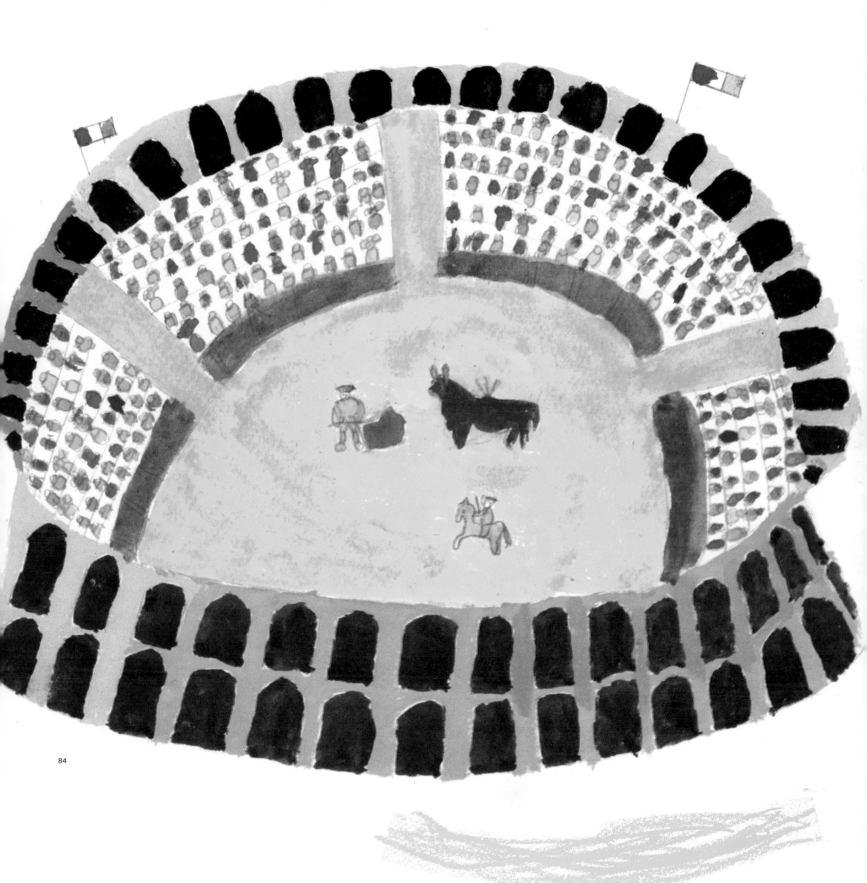

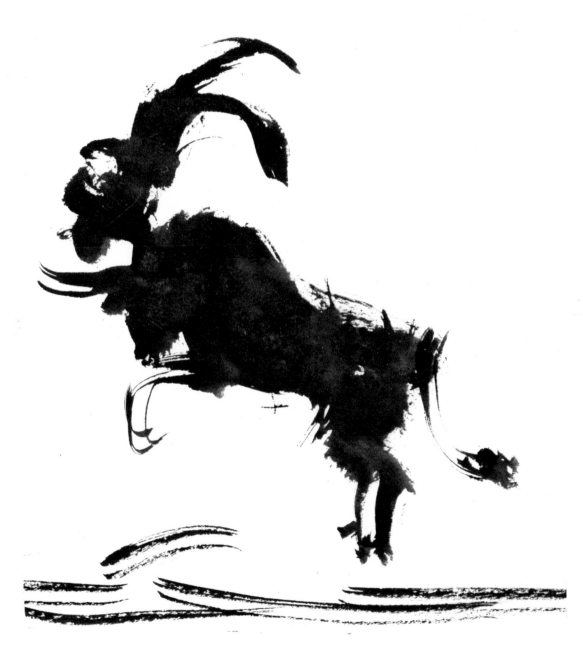

86

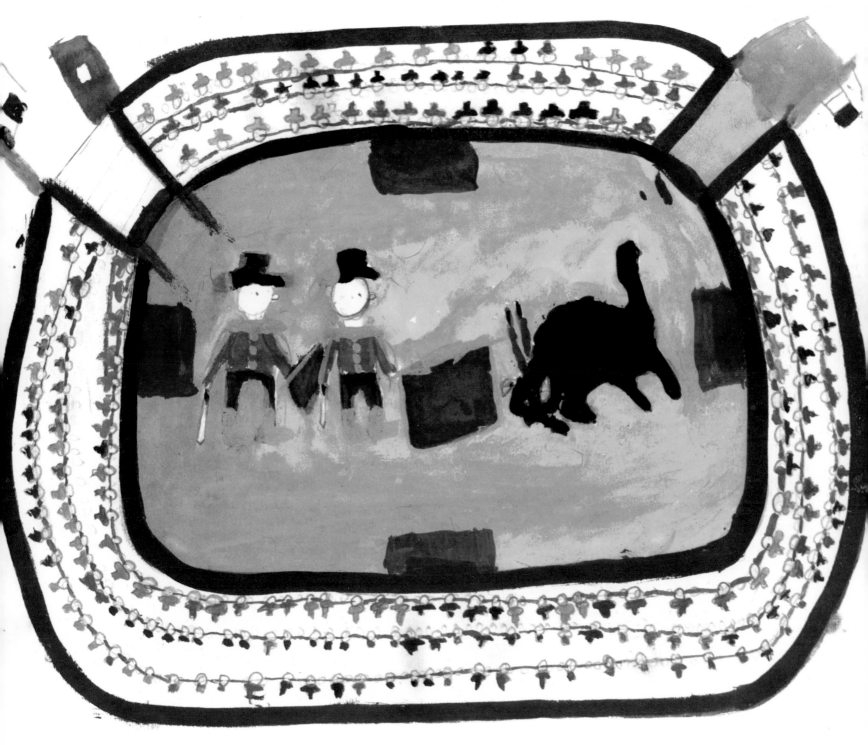

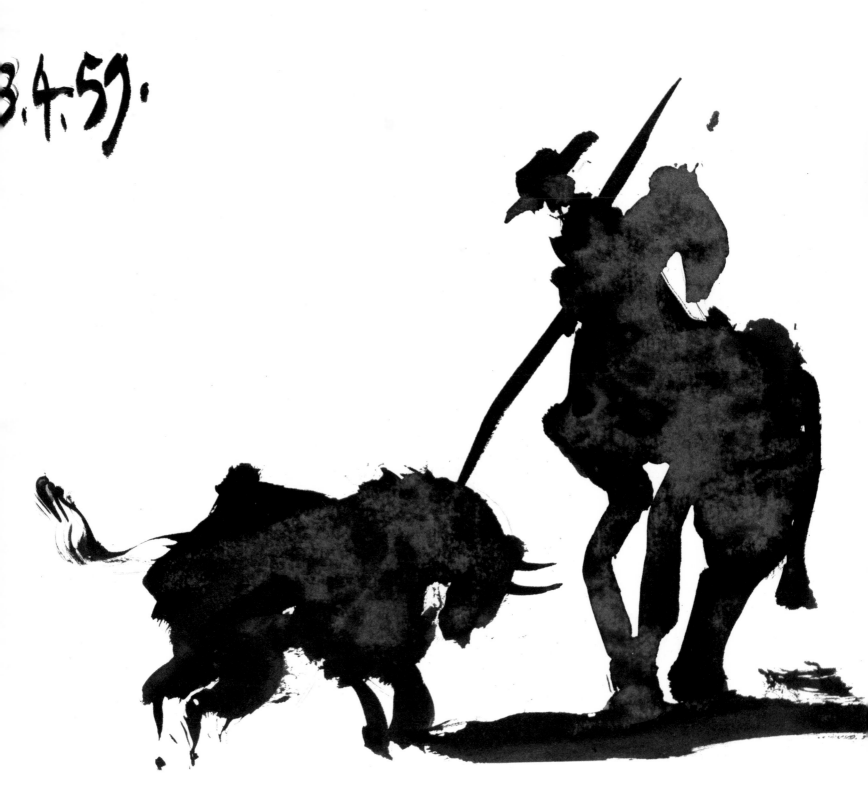

8.4.59.

87

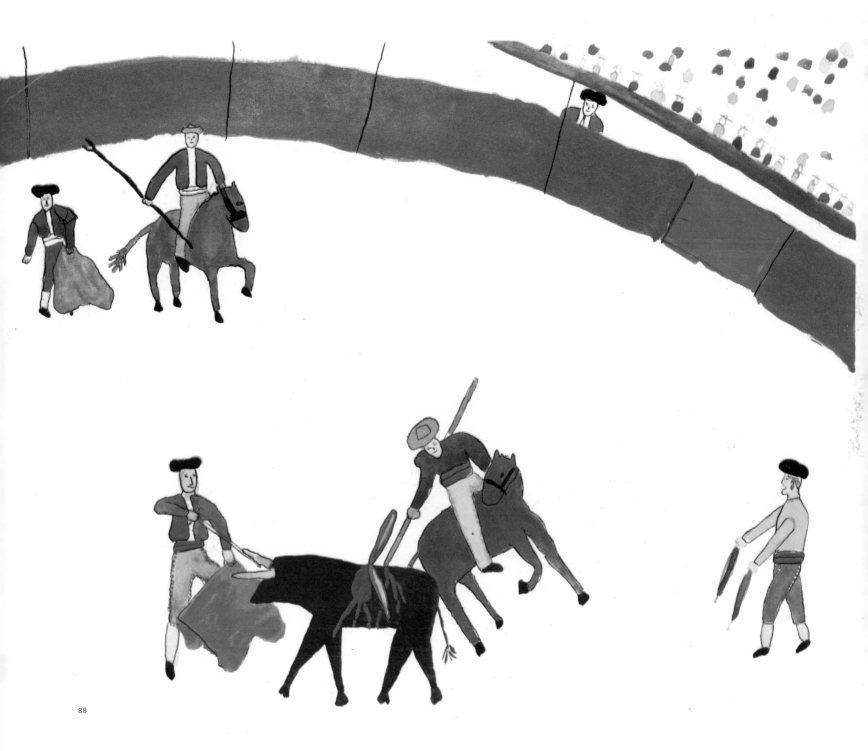

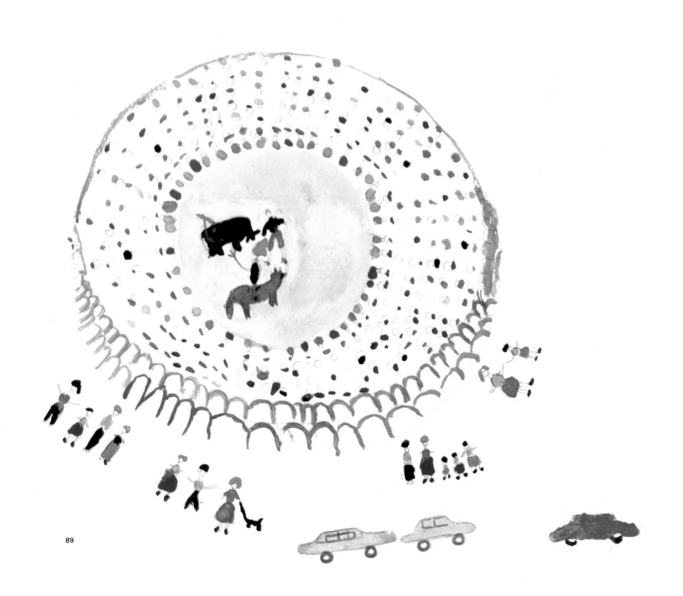

89

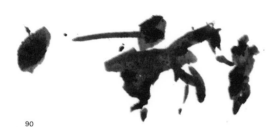

90

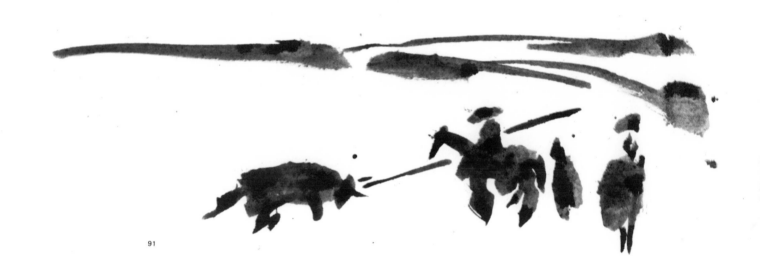

91

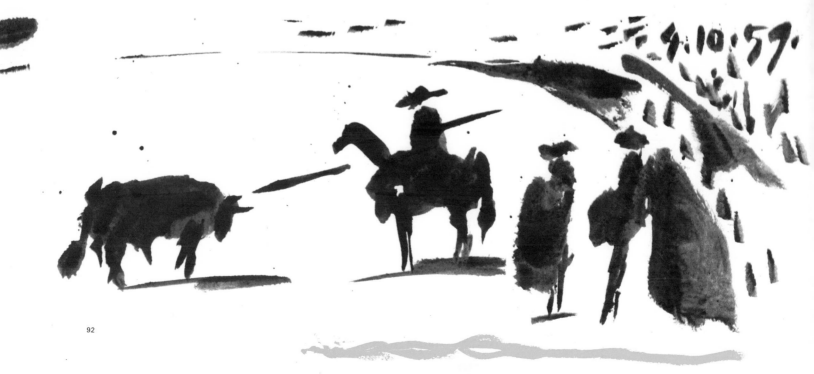

92

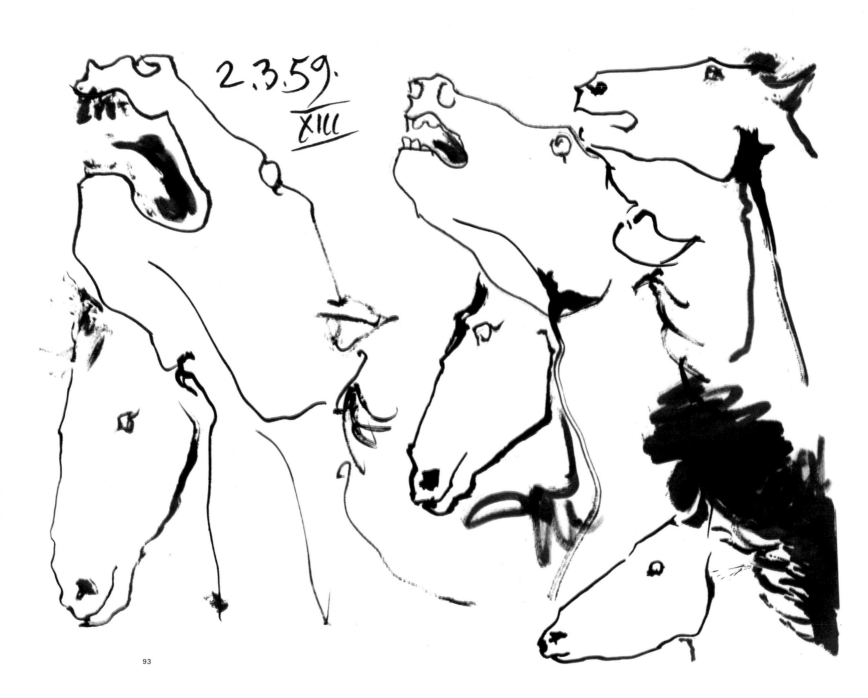

2.3.59.
XIII

93

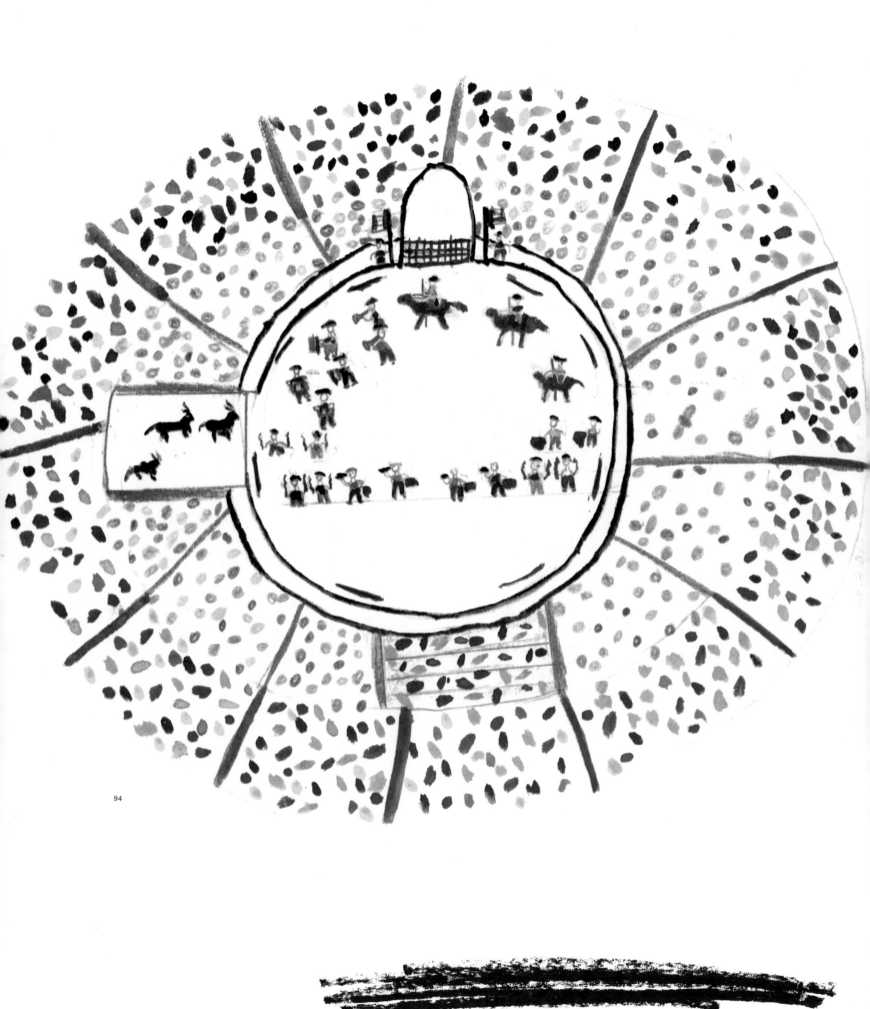

3.6.57.
VII

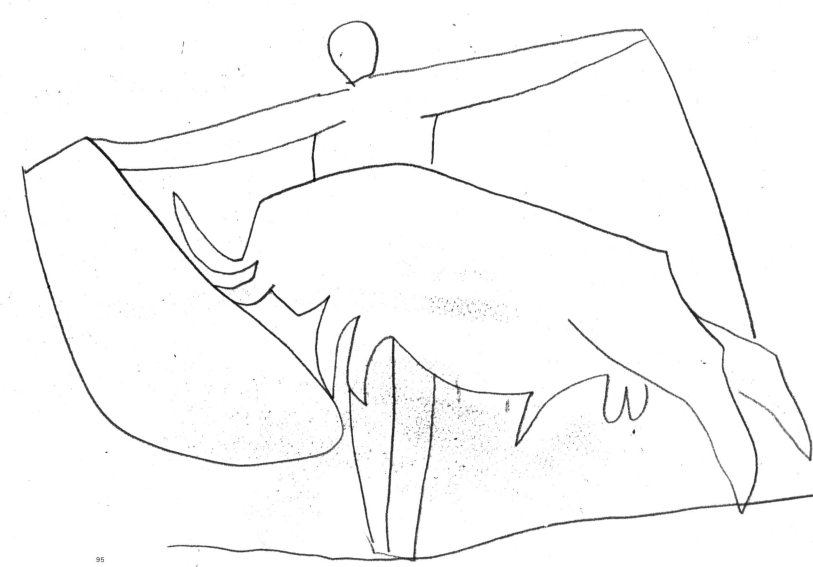

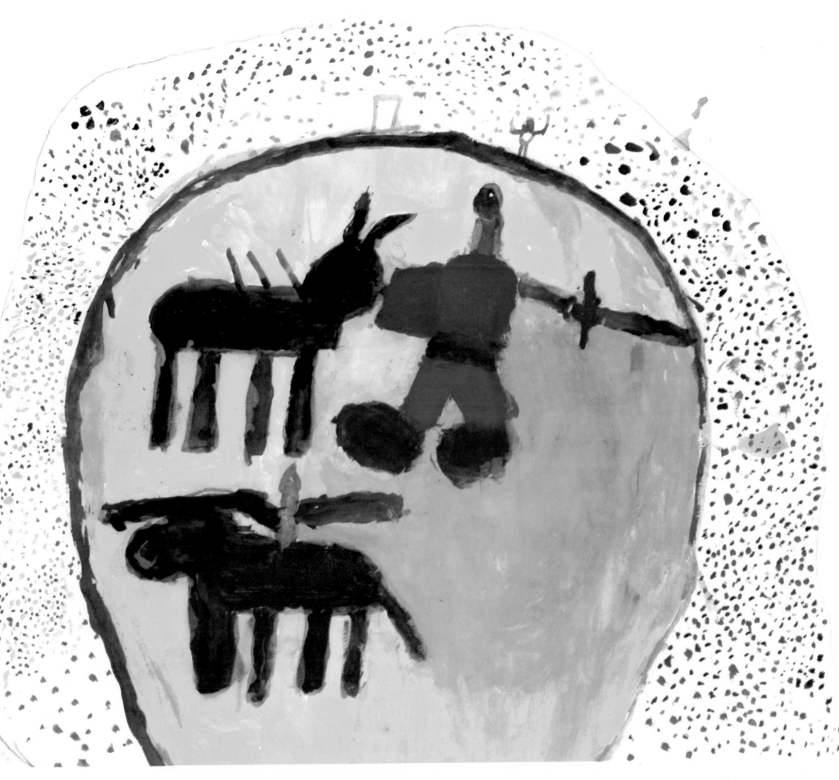

13.6.57. III

97

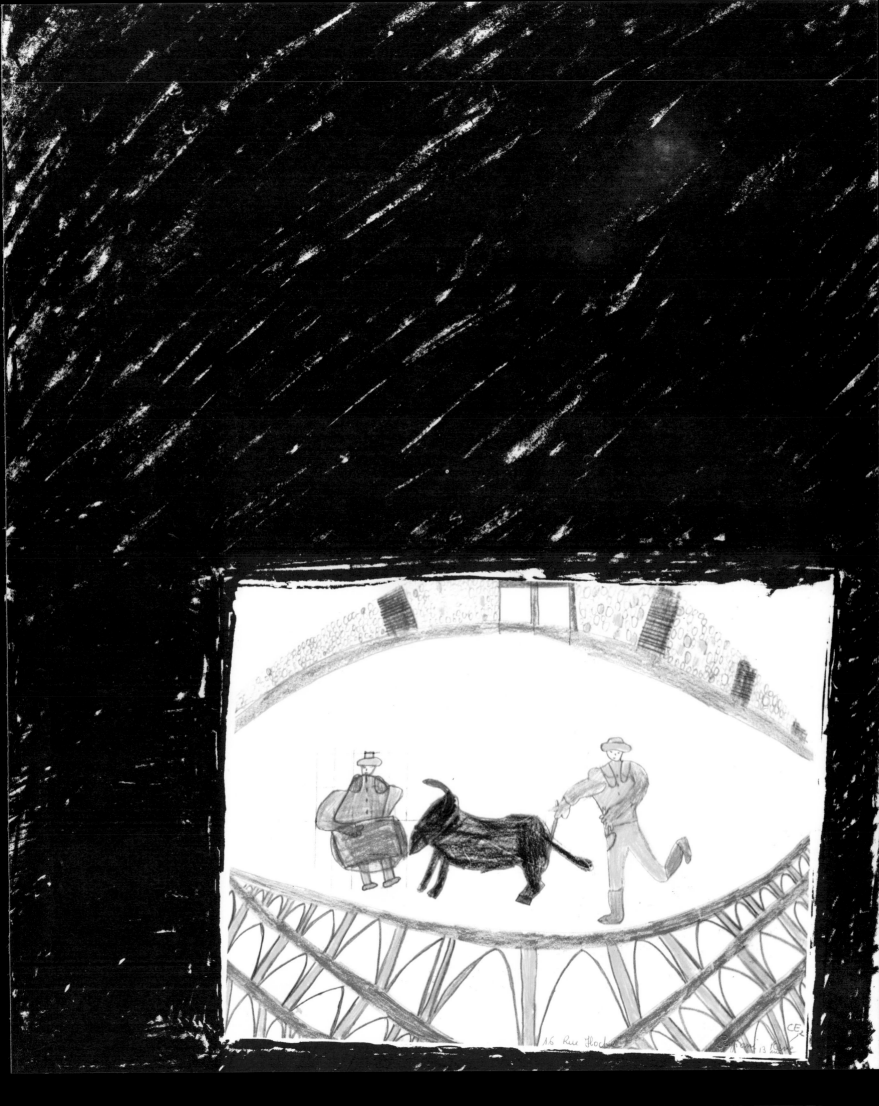

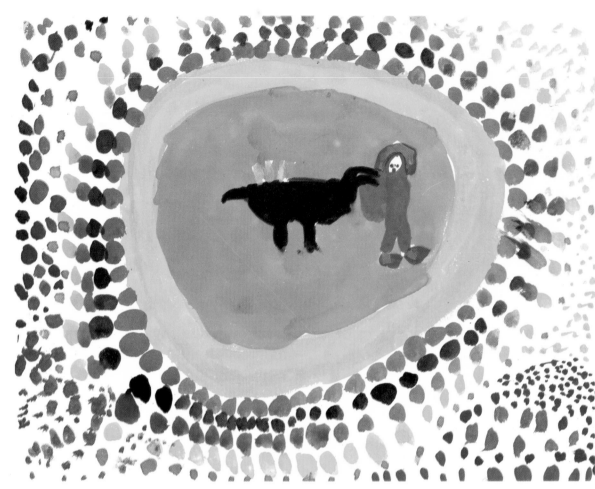

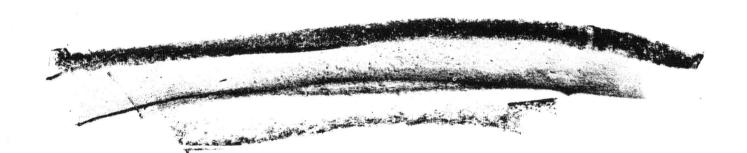

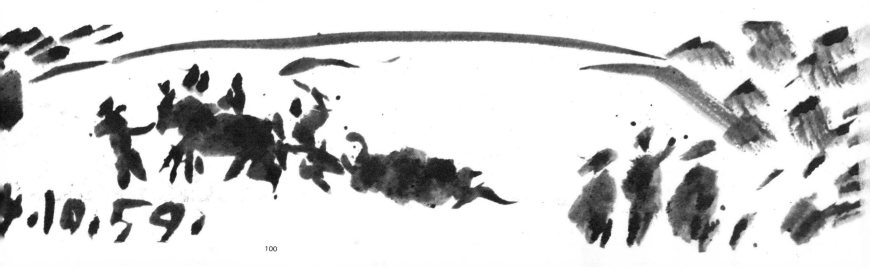

4.10.59.

LIST OF ILLUSTRATIONS